PROPERTY OF THE

Public Library of the City of Beverly.

PUBLIC LIBRARY OF THE CITY OF BEVERLY

BONO PUBLICO LÆTAMUR

1855.

WITHDRAWN

P9-ARL-312

African American Writers

AI

WILL ALEXANDER

ROBERT L. ALLEN

MAYA ANGELOU

AMIRI BARAKA

PAUL BEATTY

DAVID BRADLEY

GWENDOLYN BROOKS

ED BULLINS

BARBARA CHRISTIAN

CHERYL CLARKE

LUCILLE CLIFTON

WANDA COLEMAN

EDWIDGE DANTICAT

ANGELA Y. DAVIS

SAMUEL R. DELANY

TOI DERRICOTTE

RITA DOVE

FRANCES SMITH FOSTER

ERNEST J. GAINES

HENRY LOUIS GATES, JR.

NIKKI GIOVANNI

JEWELLE GOMEZ

ROSA GUY

FORREST HAMER

MICHAEL S. HARPER

ESSEX HEMPHILL

CHARLES R. JOHNSON

JUNE JORDAN

RANDALL KENAN

JAMAICA KINCAID

YUSEF KOMUNYAKAA

AUDRE LORDE	SONIA SANCHEZ
NATHANIEL MACKEY	SAPPHIRE
HAKI R. MADHUBUTI	NTOZAKE SHANGE
CLARENCE MAJOR	QUINCY TROUPE
PAULE MARSHALL	DEREK WALCOTT
COLLEEN J. MCELROY	ALICE WALKER
TONI MORRISON	AFAA MICHAEL WEAVER
WALTER MOSLEY	JOHN EDGAR WIDEMAN
HARRYETTE MULLEN	JOHN A. WILLIAMS
ALBERT MURRAY	SHERLEY ANNE WILLIAMS
GLORIA NAYLOR	AUGUST WILSON
BARBARA NEELY	AL YOUNG
PAT PARKER	
ISHMAEL REED	
FAITH RINGGOLD	
KALAMU YA SALAAM	

African

American Writers

PORTRAITS AND VISIONS

Lynda Koolish

Introduction by Cynthia Tucker

University Press of Mississippi / Jackson

www.upress.state.ms.us

Copyright © 2001 by University Press of Mississippi

All rights reserved

Manufactured in Canada

09 08 07 06 05 04 03 02 01 4 3 2 1

Library of Congress Cataloging-in-Publication Data

Koolish, Lynda.

 African American writers : portraits and visions / Lynda Koolish ; introduction
by Cynthia Tucker.

 p. cm.

 ISBN 1-57806-258-6 (alk. paper)

 1. African American authors—Portraits. 2. Authors, American—20th centu-
ry—Portraits. 3. African Americans—Portraits. I. Koolish, Lynda. II. Title

PS153.N5 K66 2001

810.9'896073—dc21 2001045593

British Library Cataloging-in-Publication Data available

For Thelma Hughes, who knows why—more than for anyone else—this book is for her

My photographs are a celebration of the passion, the ethical and creative genius of the writers whose work I care about. My work is intentional, deliberate, passionately subjective. Despite the intensely personal quality of my work, it is, in its deepest sense, a collaboration. I try to listen with my eyes, pay profound attention to the self that someone else is revealing to me. There is a kind of Zen spareness in my portraits, often the plainest possible backgrounds, natural light only, no gimmicks, no distractions, rarely even a visible context. As an artist, a photographer paints with light. How the subject looks psychologically and visually is determined by how the light falls, the way shadows form, creating and reflecting a sense of inner luminescence. I try to photograph at the moment of spontaneous convergence of what is visually exciting and what moves me emotionally. Sometimes, the photograph, like a poem, becomes a window filled with light.

LYNDA KOOLISH

Here, in one collection of photographs, is a stunning rebuke of the presumption, still alive in some quarters, that African Americans are not people of letters, that we have made no contributions of significance to the nation's literary canon. In the following pages, you will find portraits of some of the best American writers of our time. And they are black.

Americans of African descent have always had stories to tell. Deprived of our native languages, stripped of our religions, we kept our cultural heritage alive in the oral tradition, whether gathered around cooking fires or singing our stories as we bent low in the slave masters' fields. Soon enough, though, we learned to read and write in the alien tongue of this new land. It was not easy. Many states of the Confederacy had laws forbidding literacy among the slaves. While slave owners were always suspicious of efforts to teach enslaved persons of color to read and write, their suspicions hardened into hostility after Nat Turner's rebellion in 1831. Plantation owners believed literacy among some slaves aided the bloody uprising, and they cracked down. Virginia passed a law forbidding education not just for slaves but also for free blacks. But the oppression of slavery and forced ignorance could not silence them.

In 1761, with publication of his religious poetry, Jupiter Hammon, a slave in New York (yes, New York), became the first American of African descent to be published. But critics were not charitable toward his work, dismissing it as having faulty syntax and forced rhymes. Lucy Terry is generally considered America's first black poet. In 1746, she wrote of an Indian massacre in Deerfield, Massachusetts, in a poem called "Bars Fight." The autobiography of Gustavus Vassa, published in 1789, is also placed in the American literary canon,

though it was released in London. Vassa, born in 1745 in southern Nigeria, was kidnapped and enslaved at the age of eleven and shipped to the Americas. He eventually bought his freedom from a Philadelphia merchant and moved to England, where he campaigned against slavery.

But the best known, by far, of America's earliest black authors was Phillis Wheatley, who was a sensation in American literary circles around the time of the Revolutionary War. Born in Senegal on the west African coast in 1753, Phillis (as she was later named by her master) was kidnapped and sold into slavery as a frail child of seven or eight. Luckier than most slaves, she ended up in the household of John Wheatley, a prosperous Boston tailor, whose wife recognized the girl's intelligence and taught her to read and write. Much of Wheatley's poetry was religious in nature, but she also wrote pieces that honored famous people. Her poem, "His Excellency, George Washington," written in 1775, prompted a personal note from Washington to Wheatley.

By the 1800s, African Americans were publishing pamphlets and newspapers, the best known of which is Frederick Douglass's *North Star*. Their powerful prose and courageous activism awakened the nation's conscience to the cruelty of slavery. The polemics of lettered freedmen had another beneficial effect on the minds of white Americans: they disproved the white supremacist notion that these descendants of Africans lacked intelligence.

The writers you will see in these pages follow those traditions of storytelling, of preaching, of pamphleteering. Assembled here are photographs of poets, novelists, playwrights, polemicists. And accompanying the photographs is insightful text written by Lynda Koolish— essays that add context and texture to the pictures we

see. Koolish's familiarity with the range of writers pictured is astonishing, and she manages to capture the essence of each writer, the animating vision, the individual voice.

Koolish quotes the scholar Barbara Christian as answering her young daughter's question about her interest in other writers by saying that writers "ask questions, try to express reality as they see it, feel it, push against what exists, imagine possibilities, see things that might not yet exist." Koolish's essays examine the unique ways in which each of these writers does just that.

Though I grew up in the segregated confines of rural Alabama in the 1960s and '70s, I read black writers. My parents made sure of that. I read James Baldwin and Richard Wright. I read Maya Angelou. I read the autobiography of photographer Gordon Parks. Those books taught me that there was a world beyond Monroeville, Alabama—a world of wonder and ideas, of marvels and frights, of joy and tragedy, of defeat and triumph. And, most important for a little black girl who loved books, their works taught me there were other people, people of color, who loved letters, who created characters, who imagined other worlds. Their books taught me that there were black people who used words to question authority, to demand justice, and to crusade for freedom.

As the works of black writers illuminated my childhood, so they have sustained and inspired me in maturity, as well. I will always remember my introduction to Toni Morrison. A good friend, who happens to be white, gave me a copy of her novel, *Sula.* I was stunned by its power.

Since then, we have seen a Renaissance for black writers as publishing companies discovered that audiences were hungry for them. While many black authors still complain of stereotypes and narrow perceptions of their work, it is no longer surprising to find more than one black author featured in a local bookstore. And black authors have broken through to genres that were long thought off-limits. Walter Mosley writes mysteries; Octavia Butler writes science fiction; Iyanla Vanzant has cracked the lucrative niche of inspirational handbooks.

The African American writers featured in these pages have long been part of our lives, invoking laughter, tears, sorrow, passion, fear, anger, joy. Through their poetry and prose, we have traveled to places far and near and experienced the new and the old, the familiar and the alien. There is the poet and novelist Maya Angelou, perhaps the most photographed of the group and the most easily recognized. There is Gwendolyn Brooks, who set a standard for American letters early in the last century. There is Rita Dove, who followed Brooks's path but blazed her own trail. There is the Nobel laureate Toni Morrison, who has finally won the broad acclaim she has long deserved. There is August Wilson, whose complex characters and powerful dialogue have mesmerized theater-goers. There is Albert Murray, the great intellectual who can somehow communicate with the common man. There is Ntozake Shange, inspiration to a generation of African American feminists or "womanists," as Alice Walker might say. And there is the great "womanist," Alice Walker, herself.

We know these authors. We know their words. We can quote favorite passages from their essays, their poems, their novels. Yet, we have rarely seen their faces. We have rarely seen them reading their works, talking to audiences, explaining their views. We know some important part of them but cannot attach to it a pair of eyes, a furrowed brow, a head full of dreadlocks. Now we can look at the eyes that see so much, that transform our understanding of the world. And we can look for, even if we cannot hope to find, the source of their genius.

CYNTHIA TUCKER

African American Writers

Ai

Ai's poetry responds unflinchingly to the violence of contemporary life in a language that many find horrifying. Her dramatic monologues are transgressive, edgy, surreal, visceral. Scoundrels abound in her poems, because, as she suggests, "there's a lot more to talk about, looking at your scoundrels."

Despite the disclaimer to *Vice: New and Selected* (1999) that her poems "do not denote or pretend to private information about actual living persons," her poetic narrators include a wide range of identifiable victims and perpetrators of violence: among them, an ex-football player driving too fast in a white Ford Bronco; Manhattan Project leader J. Robert Oppenheimer; Mary Jo Kopechne, whose appearance serves to reminds us that this "melodrama" is about *her* life, not Edward Kennedy's; and Lyndon Johnson, whose squalid dreams of Vietnam are those of a sexual predator. The violence of her images, however, is not gratuitous. Ai insists, "I do not write about race, social comment, etc., but about people, life, suffering, and am now trying to bring about the transfiguration of men and women in my poetry."

In "Before You Leave," Ai assumes the persona of a woman who is powerfully strong, not traditionally "feminine": "You can bite me, I won't bleed." In "The Country Midwife: A Day," a callous midwife offers a chilling description of childbirth: "A scraggly, red child comes out of her into my hands / like warehouse ice sliding down the chute." The poem "Lesson, Lesson" speaks in the hardened voice of an impoverished, exhausted mother who warns her child that next year, there will be one more "little-gimme-fill-my-belly / . . . because your daddy a hammer. / Hard-time nail in his pants. / He feel wood beneath him, he got to drive it home." Ai reveals

to her readers a troubled universe, a world of hidden pain and denied suffering, but also one of sometimes startling empathy. In "She Didn't Even Wave," for example, a poem dedicated to Marilyn Monroe, Ai imaginatively and compassionately embraces Monroe as emotional kin. Her first book, *Cruelty*, published in 1973 to great critical acclaim, was followed by *Killing Floor* (1979), the Lamont Poetry selection of the Academy of American poets. Other collections of her poems include *Sin* (1986), *Fate: New Poems* (1991), and *Greed* (1993), which opens with "Riot Act, April 29, 1992," a poem about the aftermath of the Rodney King beating, its narrator a South Central Los Angeles rioter, caught by the police but nonetheless ruefully grateful for "the day the wealth finally trickled down." *Vice*, her most recent volume, won the National Book Award. She recently completed a quartet of poems about the 1921 Tulsa race riot (an event that also provoked the literary imagination of Toni Morrison, who alludes to it in her novel, *Paradise*).

Japanese, Choctaw, Southern Cheyenne, and Comanche Indian, as well as Dutch, Irish, and African American, Ai, whose name means "love" in Japanese, was born in 1947 in Albany, Texas, and lives in Stillwater, Oklahoma, where she is a tenured full professor at Oklahoma State University. This photograph was taken in the mid 1990s at "Border Voices," San Diego's annual celebration of poetry and music.

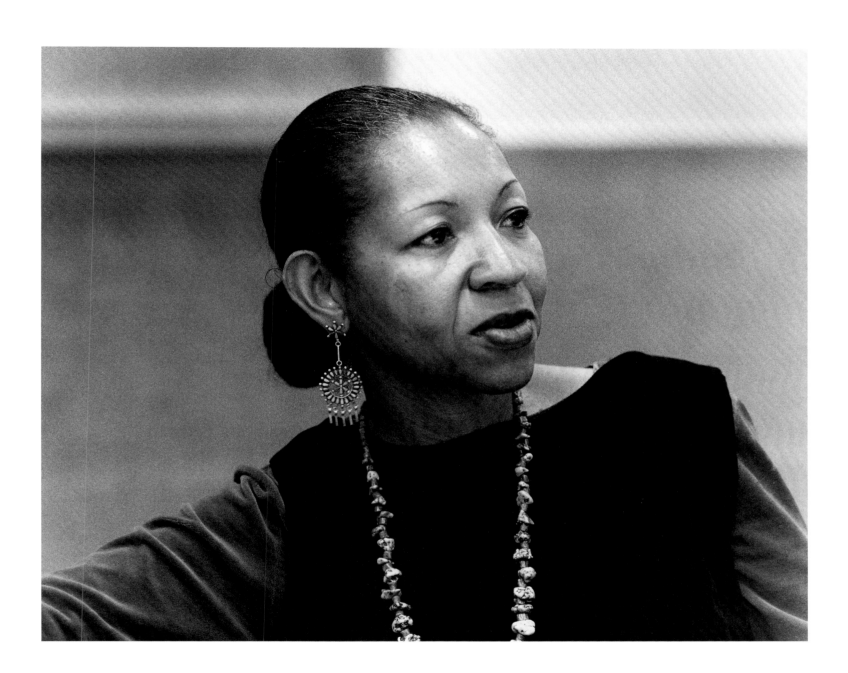

Will Alexander

Will Alexander pushes language and philosophy till the seams fray, stretching old systems of sense into a quilted collage of meanings. In his first books, *Vertical Rainbow Climber* (1987) and *Arcane Lavender Morals* (1994), his poetry not only records but also recodes. Alexander seems to engage every system of language at once. His most recent book of poetry, *Above the Human Nerve Domain* (1998), constructs a poetry from the languages of astronomy, nuclear physics, cellular biology, and philosophy. The glossary provides the reader with a handful of lexical footholds, for example: *"Aleph* is a number greater than the number that is greater than infinity." The poems, however, ultimately transcend the need of a glossary, as words become unmoored from their old meanings. Alexander is an alchemist who turns leaden technical language into poetic platinum.

In Alexander's *Asia and Haiti,* a two-poem edition from Sun and Moon Press, philosophy, spirituality, politics, and history are woven together so that the reader is forced to realize that they have never been separate issues. These poems critique both communism and capitalism, but instead of locating this critique in a falsely objective perspective, Alexander uses a collective voice to engage in the rituals of resistance. *Asia* is delivered in the "voice of rebellious Buddhist monks," while in *Haiti*, the collective voice belongs to *Les Morts*, "the unnamed dead," Haitians tortured and killed during the rule of Papa Doc Duvalier.

Andrew Johnson's essay "On Alexandrian Philosophy," the introduction to Will Alexander's *Towards the Primeval Lightning Field* (1998), discusses Alexander's approach to rhetoric: "Alexander's methodology here is neither deductive nor inductive, but *conductive*. Thesis passes into antithesis with electric fluidity, never terminating in synthesis: the relationship between statements is nonhierarchical and non-cumulative." The text itself illustrates this conductive method with a startling and erudite difficulty Johnson's description could not encapsulate: "The old chronological towers are ash, are prisms of disfigurement, symbolic of a world cancelled by consumptive inmelodias. As for alchemical transition, we face the raising of new sea walls, of banished and re-engendered electorates, trying to cope with new intensities of weather, as the anomalous hypnotically increases with the power of inverse subjective. . . . And so, I speak of a new being of symbols, of lucid catacombs and spirals, its language being spun in fabulous iguana iridium." Born in Los Angeles in 1948, Will Alexander is currently a visiting professor of writing at the University of California, in San Diego. This photograph was taken at the San Francisco Book Fair in 1999.

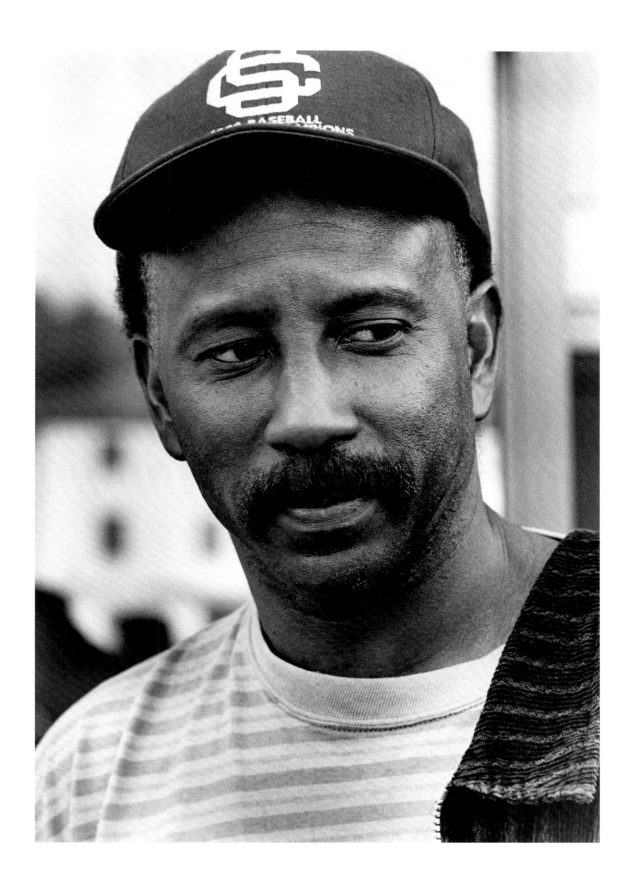

Robert L. Allen

Robert Allen, activist, social reformer, and editor for the *Black Scholar*, not only records social change, but also facilitates it. In an interview Allen commented on the way in which participating in sit-ins and demonstrations influenced his later work: "I became very interested in how the system of social segregation came to be, how society works, how social change movements develop. That experience in the civil rights movement was a major factor pushing me to become interested in studying social change."

His first book, *Black Awakening in Capitalist America* (1969), a study of the black freedom movement of the 1960s, charts the course of a social revolution, a process he describes in the book's introduction as "never direct, never a straight line proceeding smoothly from precipitating social oppression to the desired social liberation." For this project, Allen examined the relationships among ideologies of Black Power, Black Nationalism, and corporate imperialism. The arguments in this book are both complemented and complicated by Allen's 1974 collaboration with Pamela Allen, in *Reluctant Reformers: Racism and Social Reform Movements in the United States*, a study of the ideological impact of racism on predominantly white social reform movements.

In 1977 Allen was awarded a Guggenheim that he used to begin the research for the text that would become his celebrated and award-winning 1989 book, *The Port Chicago Mutiny*. Allen's detailed study of this event was the primary inspiration for the award-winning documentary *Port Chicago Mutiny: A National Tragedy*, a dramatic exploration of the U.S. Navy's egregious and discriminatory World War II ammunition loading policy. Black enlisted men were the only ones assigned to the dangerous task of loading ammunition into the liberty ships, and few safeguards were in place; white officers frequently hurried the process along as a kind of mock athletic contest. Allen revealed the courage of one loading crew who refused to return to work after an accident resulting in the deaths of many of their coworkers. The Navy convicted many of these sailors on charges of mutiny and treason, sentencing them to long prison terms. No official investigation into the Port Chicago mutiny was conducted until Allen brought this near-forgotten tragedy to light. The unjustly convicted men were then finally granted a presidential pardon.

In 1995 Robert L. Allen co-edited, with Herb Boyd, *Brotherman: The Odyssey of Black Men in America*, an anthology that includes nearly 150 writers discussing, reflecting, and constructing the collective experience of black men.

Born in Atlanta in 1942, Allen lives and works in San Francisco, where he is a senior editor at the *Black Scholar*. This photograph was taken in San Francisco in 1988, at a book party for Alice Walker's children's book *To Hell With Dying*.

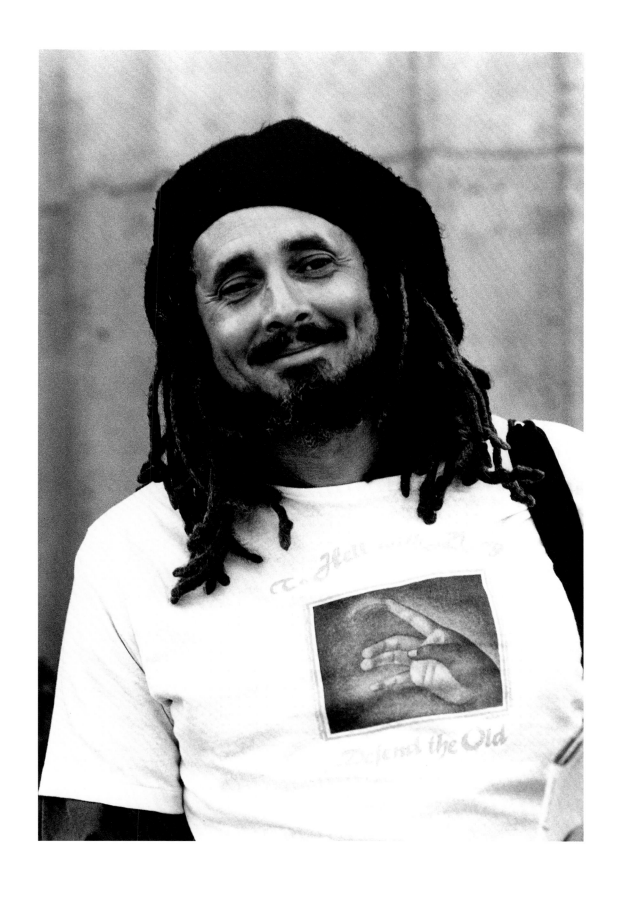

Maya Angelou

Maya Angelou's writing is a public record of a private life. Poet, filmmaker, a dancer who studied with Martha Graham, singer, actress, and much beloved autobiographer, Angelou writes of her fierce, all-powerful grandmother as a kind of implacable warrior in *I Know Why the Caged Bird Sings* (1970): "Momma said she wanted to see Dentist Lincoln and to tell him Anne was there. The girl closed the door firmly. Now the humiliation of hearing Momma describe herself as if she had no last name to the young white girl was equal to the physical pain. It seemed terribly unfair to have a toothache and a headache and have to bear at the same time the heavy burden of Blackness." In the memoir/fable of her life in Stamps, Arkansas, the young Marguerite imagines her Momma extracting a tremulous apology from Dentist Lincoln with more cool, cerebral skill than any dentist could ever hope to display in the mere act of tooth extraction!

This first volume of her autobiography, later adapted for television, was followed by *Gather Together in My Name* (1974), *Singin' and Swingin' and Gettin' Merry Like Christmas* (1976), and the much admired *The Heart of a Woman* (1981). In her 1986 volume, *All God's Children Need Traveling Shoes*, a geographic inversion of traditional slave narratives, Angelou travels from America to Africa, bent on a journey to self-discovery, identity, and freedom. Describing her stay in Ghana, she powerfully relates the story of encountering a Kita woman unshakably convinced by Angelou's appearance that Angelou must be from the tribe of Kita villagers: "Descendants of a pillaged past saw their history in my face and heard their ancestors speak through my voice. . . . Now I knew my people had never left Africa. We had

sung it in our blues, shouted it in our gospel. . . . It was Africa which rode in the bulges of our high calves, shook in our protruding behinds and crackled in our wide open laughter." More recent additions to this body of work include *Wouldn't Take Nothing for My Journey Now* (1993) and *Even the Stars Look Lonesome* (1999).

Angelou's first book of poetry, *Just Give Me a Cool Drink of Water 'fore I Diiie* (1971), was nominated for a Pulitzer Prize. *The Complete Collected Poems of Maya Angelou* (1994) includes the Clinton inaugural poem, "On the Pulse of Morning," and selections from her other five volumes of poetry: *Oh Pray My Wings Are Gonna Fit Me Well* (1975), *And Still I Rise* (1978), *Shaker, Why Don't You Sing?* (1983), and *I Shall Not Be Moved* (1990).

Nominated for an Emmy in 1977 for her performance in *Roots*, she made her feature film directorial debut with *Down in the Delta* in 1998.

Born Marguerite Johnson in 1928 in St. Louis, Angelou is currently the Reynolds Professor of American Studies at Wake Forest University. The author of several plays and many children's books, she says of her work: "I write for the Black voice and any ear which can hear it." This photograph was taken at the Berkeley Community Theater in 1994 at a fundraiser for the progressive Berkeley mayoral candidate Don Jelenik.

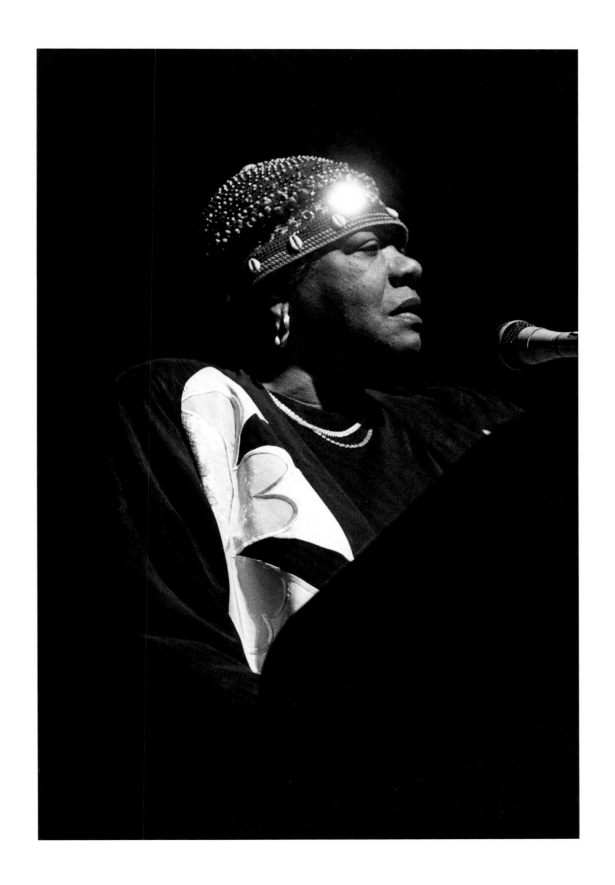

Amiri Baraka

A moving target is harder to hit, and Amiri Baraka, poet, playwright, critic, musicologist, and ideologue, has been consistently in motion since he first made his public appearance with his Beat-inspired poetry collection, *Preface to a Twenty Volume Suicide Note* (1961). While his artistic power has never been in doubt, its alliance, and often subordination, to the shifting ideologies that Baraka has embraced since the 1960s has discomfited readers who like their art and their politics in air-tight containers. Baraka himself acknowledges the movement: "The typology that lists my ideological changes . . . as 'Beat-Black Nationalist-Communist' has brevity going for it, and there's something to be said for that, but, like the notations of [Thelonius] Monk, it doesn't show the complexity of real life." Nothing could be more complex than Baraka's intense, searching, vibrant intellect and the torrent of art and commentary it has produced.

Baraka's Black Nationalist period has been his most influential. His poetry, drama, and cultural and political activity dominated African American letters during the 1960s and '70s, defining the Black Arts Movement and guiding the next generation of writers who came of age under its influence. His incendiary play, *Dutchman* (1964), portraying a surrealistic confrontation between a white woman and a black man, exposed a violent, complex, and emotional racism that America had never before seen on stage. Critic Carl Brucker suggests both the setting and title of the play "remind the audience of the packed holds of Dutch slave traders, which brought the first African to Jamestown; the historic Underground Railroad, which helped slaves escape the South; and the legendary *Flying Dutchman*, the cursed phantom ship which endlessly sails the seas." As Baraka moved further into black radicalism, the loose poetic form he had inherited from the Beats dissolved altogether; language itself sometimes slipped its logocentric moorings—any hint of l'art pour l'art dissolved by Baraka's rage: "We want 'poems that kill.' / Assassin poems. Poems that shoot / Guns. Poems that wrestle cops into alleys / And take their weapons leaving them dead / With tongues pulled out and sent to Ireland. Knockoff / Poems for dope selling wops or slick halfwhite / Politicians. Airplane poems, rrrrrrrrrrrrr / rrrrrrrrrrrrrrrr . . . tuhtuhtuhtutuhtuhtuh-tuhtuhtuhtuh / . . . rrrrrrrrrrrrrrrrrrrrrrrr . . . Setting fire and death to / whities ass."

But rage is only a part of Baraka's repertoire. A lover, a preacher, a musician, and, above all, a seeker, he doesn't always take his audience where he himself has been, but the journey is always moral, always heartfelt, and frequently—though this might be the least important element to Baraka himself—beautiful.

Baraka's prolific output includes the jazz history *Blues People* (1963), the essays collected in *Home* (1966), the nationalist poetry collection *Black Art* (1966), the plays *The Toilet* (1964) and *The Slave* (1964), and *The Autobiography of LeRoi Jones* (1984). Baraka was born LeRoi Jones in 1934 in Newark, New Jersey. This photograph was taken in May 2000 at the Malcolm X Jazz Arts Festival in Oakland.

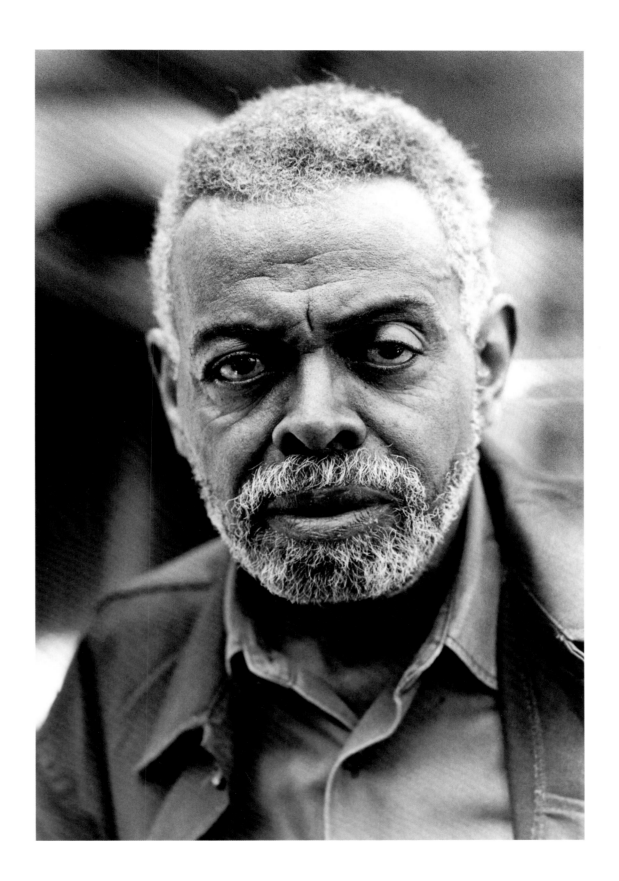

Paul Beatty

Comic genius Paul Beatty, victor of the 1990 New York Poetry Slam, is the author of *Big Bank Take Little Bank* (1991), poems that thrive on wit, invention, and invective. "This Side Up" is a powerful indictment of the moral vacuousness and spiritual poverty of America: "on the corner / 138 and st. nick / i caught america with her panties down / peeped under her dress / and saw a cardboard one person shantytown." The poem's persona—an enraged black man who is literally tempted to sexually violate an America which has despised him— reads as an intertextual riff on Gwendolyn Brooks's "love note II: flags" ("I pull you down my foxhole. Do you mind?") and Ralph Ellison's protagonist in *Invisible Man*, who wants to both caress and destroy the naked blond woman tattooed with an American flag. Beatty's poems also rage madly across the page in *Joker, Joker, Deuce* (1994), repudiating corporate culture and critiquing the movie *Field of Dreams* for perpetuating and celebrating a history of baseball that was played out on fields labeled "whites only."

Beatty has retained this acerbic, witty hip-hop/performance poetry approach in his prose, drawing from urban vernacular to tap a comic ultrarealism and reinventing satire and irony to turn accepted "truths" inside out, exposing a clear view of the shoddy stitch work that holds them together. In his first novel, *The White Boy Shuffle* (1996), Beatty examines the political legacy of the past two decades through the self-described "cool black guy" Gunnar Kaufman, "the number-one son of a spineless colorstruck son of a bitch," schooled during the apex of multicultural education: "During Black History Month, to put a class of toothless urchins in touch with our disparate niggerhoods, Ms. Murphy assigned us to make family trees." Gunnar recounts the story of his great, great uncle, Wolfgang, who—in Beatty's fabulous masculine version of Paule Marshall's "poets in the kitchen"—introduces two white boys to a group of cabbies on their lunch breaks "telling hilarious, if only slightly exaggerated stories of black life in a big city," thus providing the boys with the idea for the "Amos 'n' Andy" show. Gunnar's move from the upperclass Santa Monica area to the less privileged and certainly more diverse LA community of Hillside transforms him into a wise-ass, safe-cracking, "punked for life" gang member, basketball star, accomplished poet, father, college student, and political leader—roles that provide Beatty with the opportunity to satirize these diverse arenas of American life.

In *Tuff* (2000) Winston "Tuffy" Foshay, the 320-pound nihilistic gang member, takes all of center stage. As the novel develops, Tuffy runs for City Council as a way to rail at the system from the fringes (as well as to pocket the $15,000 dangled in front of him to do so): "I ain't saying waste your vote on me, because I ain't the somebody that give a fuck, but you need to vote for somebody."

Paul Beatty has an MFA from Brooklyn College and lives in New York. This photograph was taken at Modern Times Bookstore, in San Francisco, in May 2000.

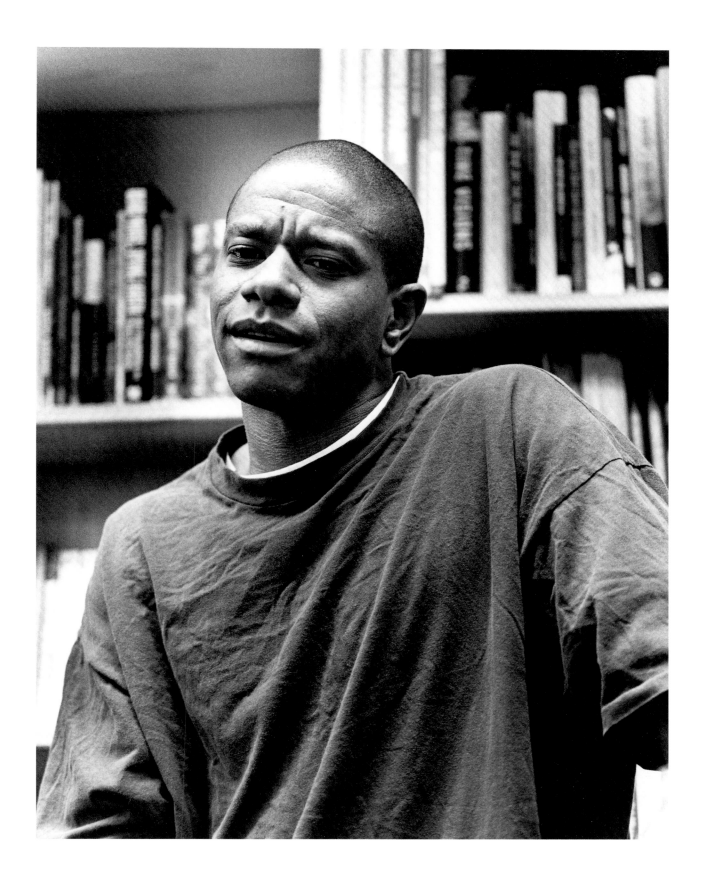

David Bradley

Like Ralph Ellison, David Bradley's literary reputation rests upon the achievement of one remarkable novel, *The Chaneysville Incident* (1981). Narrated by a black historian, John Washington, *The Chaneysville Incident* is based upon the legend, confirmed by the historical work of Bradley's mother, of thirteen runaway slaves who committed mass suicide in Bedford Country, Pennsylvania, at the point of their imminent recapture. Though the "incident" itself was historically verified, Bradley makes it the basis of a complex, wrenching quest into the center of African American experience through a fictionalization which turns the narrator into the descendent of one of the suicides. The fictionalization itself becomes the word made flesh through the imaginative recreation that turns the lifeless historical notecards compiled by the narrator into a harrowing account of final flight and tragedy.

This passionate and personal excavation allows the black historian to wrest the image of his or her people from white narratives that relegate African Americans to the status of slaves or victims, or—as in the incident at Chaneysville—cast them into oblivion. Rejecting the official narrative allows the black historian (and artist) to write out of a compassionate not-knowing that avoids the falsification of unexamined assumptions. As John Washington reflects: "For any complex issue is surrounded by a maze of questions, most of them obvious, most of them meaningless, and all of them false. A bad historian picks the wrong ones and spends his time researching the useless. A mediocre historian tries to answer them all and spends his time doing background for conclusions that, when stated, will seem hopelessly obvious. A good historian looks at the issues and does . . . nothing. He sits and thinks and tries to find the few questions that are significant and central, hoping that one is so much a cornerstone that answering it will answer all the rest."

It was appropriate that *The Chaneysville Incident* won the 1982 PEN/Faulkner Award, for Bradley reads through Faulkner to re-voice his African American take on the individual mind as shaped by and resistant to community, the freighted complexity of interracial relationships, and the intimate knowledge of a physical landscape in which one is both hunter and quarry.

Bradley is the author of an earlier novel, *South Street* (1975), which explores the life of a Philadelphia ghetto through a remarkable montage of characters and vernaculars. He was born in 1950 in Bedford, Pennsylvania, and currently lives and writes in La Jolla, California. This photograph was taken in February 1999, in Lynda Koolish's graduate seminar on contemporary African American literature at San Diego State University.

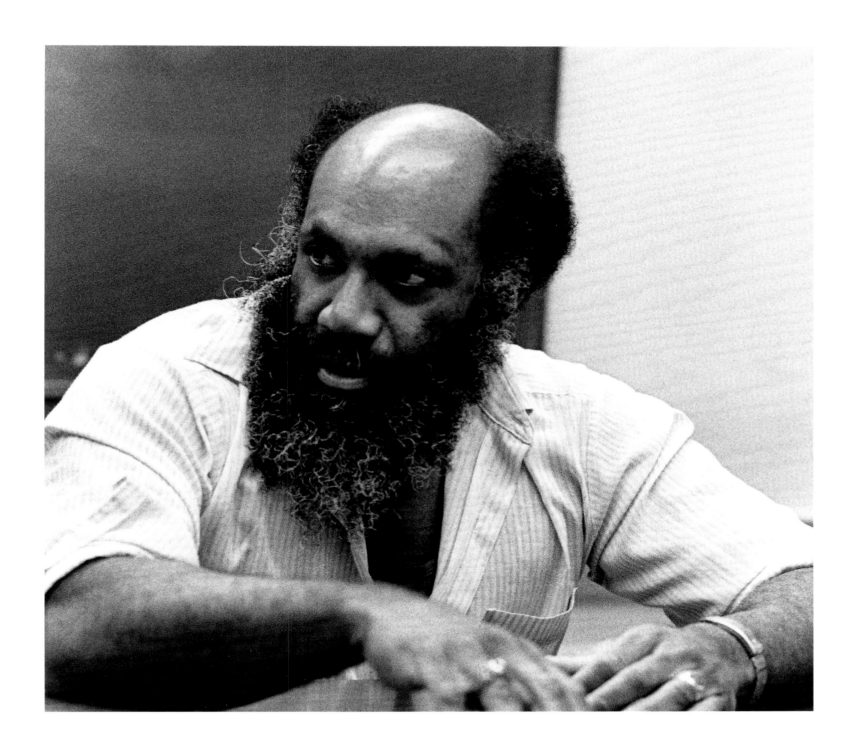

Gwendolyn Brooks

"In the breath / Of the holocaust he / Is helmsman, hatchet, headlight," Gwendolyn Brooks wrote of Langston Hughes (*In the Mecca*, 1968), praising him with an economy of precision and a command of poetic technique that mark both poets' literary careers. Although Brooks later offered an apologia for what she termed "certain little timidities of my *own* in the late Forties," even her earliest poems were marked by a fierce racial awareness uneclipsed by her final volumes *The Near-Johannesburg Boy and Other Poems* (1986), *Winnie* (1988), and *Gottschalk and the Grande Tarantelle* (1988).

With *A Street in Bronzeville* (1945), Gwendolyn Brooks established herself as a leading voice in American poetry, focusing on the compressed, variegated world of Chicago's South Side. A formidable master of poetic forms—sonnets, ballads, terza rima—Brooks presents the uncertainties of characters who defend themselves against an inner and outer chaos. Long before novelist Toni Morrison created the character Sethe, Gwendolyn Brooks stunned her readers by creating "the mother," a character whom she described in her autobiography (*Report from Part One*, 1972) as "a mother not unfamiliar, who decrees that *she*, rather than her World, will kill her children." This first collection contains some of the greatest American war poems ever written: "Negro Hero" ("I had to kick their law into their teeth in order to save them") and "Gay Chaps at the Bar," a twelve-poem sonnet sequence that confronts readers, via her protagonists' ironic observations, with the emotions of African American soldiers who fought for a country reluctant to respect them as equals. Brooks created understated indictments of the willful myopia of the privileged white Chicagoans whom her working-class black protagonists encounter.

In 1950 Brooks became the first African American to be awarded a Pulitzer Prize, receiving that honor for *Annie Allen* (1949). *The Bean Eaters* (1960) contains both the deservedly famous "We Real Cool" and "A Bronzeville Mother Loiters in Mississippi. Meanwhile, a Mississippi Mother Burns Bacon," still the defining poem on the death of Emmett Till.

After Brooks's 1967 Black Arts conversion, her prosody grew looser, and she gravitated toward a relatively colloquial free verse. "The Boy Died in My Alley" (*Beckonings*, 1975) explores violence by focusing on the issue of individual transformation. The literal cause of the death of a black boy, whose blood "ornaments [the poet's] alley," remains unmentioned, a fact encouraging the reader to consider the multiple ways in which young black men in this country mysteriously end up dead: alcohol and drugs, gang warfare, robberies gone awry, police violence, suicide. The poet acknowledges a sorrowful and determined responsibility for the death of the boy and in so doing teaches each of us the tragic consequences of "knowledgeable unknowing," of ever failing to act against oppression and violence. Her tribute to Paul Robeson, clearly applicable to Brooks's own work as well, confirms this powerful sense of commitment, community and love, honoring an art that "Warn[s], in music-words / devout and large / that we are each other's harvest . . . / we are each other's magnitude and bond."

Though known chiefly as a poet, Gwendolyn Brooks also wrote the novel *Maud Martha* (1953). She was born in Topeka, Kansas, in 1917. She died in 2000. This photograph was taken in San Francisco circa 1980.

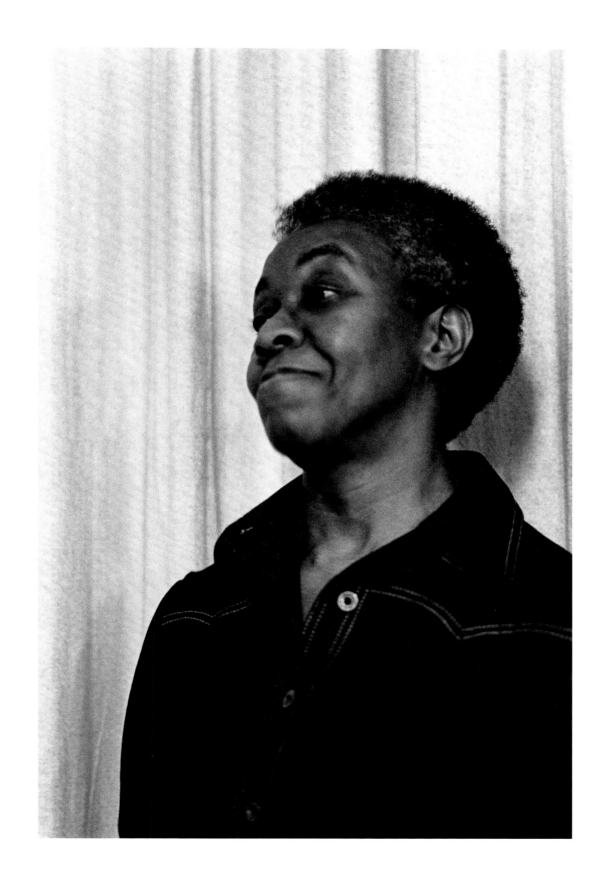

Ed Bullins

Ed Bullins fought his way up from the streets he so unsparingly portrays in his drama and came back from the dead in more ways than one; as a junior high student in Philadelphia, where he grew up, Bullins was stabbed in a fight and almost died. A high-school drop-out in the early 1950s, he wrote his way into the center of the burgeoning Black Arts Movement by recording the brutalized human comedy of black oppression in dialogue and character that resonated far beyond the limited horizons of the men and women trapped within. The mangled lyricism of the embittered ex-navyman, Cliff, shines all the more starkly against the profanity, drunkenness, violence, and lust unanchored in emotion that makes up the rest of *In the Wine Time* (1968): "And the nights . . . ahhh . . . the nights at sea, boy. Ain't nothin' like it. To be on watch on a summer night in the South Atlantic or the Mediterranean when the moon is full is enough to give a year of your life for, Ray. The moon comes from away off and is all silvery, slidin' across the rollin' ocean like a path of cold, wet white fire straight into your eye."

Bullins writes from the heart of the black aesthetic, but the same penetration that lifted him out of the ghetto skewers all rhetoric, including that of black nationalists who talk the talk but don't walk the walk. With more than seventy plays to his credit, over half of which have been professionally produced, Bullins is among the most gifted and prolific dramatists of our times. His plays incorporate all of the techniques of modern drama from agitprop to naturalism to the absurd. While writing to the condition of the "street nigger" he claims as his special territory, Bullins has engaged the attention of the professional theater world as well. He has garnered two Obie awards, one jointly awarded in 1971 for *In New*

England Winter (1969) and *The Fabulous Miss Marie* (1971) and the other for the 1975 production of *The Taking of Miss Janie*. Other important plays include *Clara's Ole Man* (1965), *Goin' a Buffalo* (1968), and *Boy X Man* (1995).

Born in Philadelphia, Pennsylvania, in 1935, Bullins joined the U.S. Navy, then enrolled in school in the San Francisco Bay area during the sixties. Here he helped create the cultural nationalism of the Black Arts Movement. As playwright-in-residence for the Harlem-based New Lafayette Theater from 1967 to 1973, Bullins created plays, anthologies, and symposia that spawned the tidal wave of black theater that subsequently washed through every American city. In 1995 Northeastern University appointed Bullins professor of theater. This photograph was taken at the photographer's home in Berkeley, California, in August 2000.

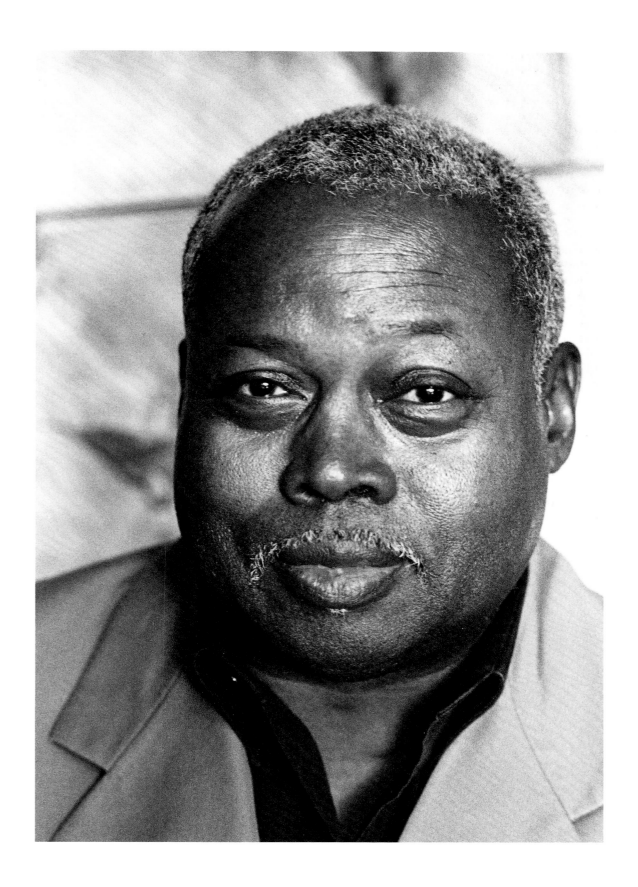

Barbara Christian

In the introduction to her 1985 study, *Black Feminist Criticism*, Barbara Christian answered her then ten-year-old daughter Najuma's question about what it is, exactly, that writers do, and why her mother reads and writes about writers, by noting that writers "ask questions, try to express reality as they see it, feel it, push against what exists, imagine possibilities, see things that might not yet exist." Among the most articulate, visionary, and path-breaking social historians and literary critics writing primarily about black women writers, Barbara Christian, who died at age fifty-six on June 25, 2000, was a much beloved teacher of both African American studies and ethnic studies at University of California, Berkeley (and the first black woman to receive tenure there). She cared passionately about literature and believed in its capacity not only to perceive, reflect, and perpetuate individual and social reality, but to *change* that reality.

Christian helped readers to see that Najuma's life—and all of our lives—will be radically different because writers like Zora Neale Hurston, Alice Walker, Audre Lorde, Paule Marshall, Toni Morrison, Gloria Naylor, and Buchi Emecheta (the subjects of some of her critical writing) are changing black women's perceptions of themselves, are among those insisting, "not only that white society must change, but also that the black communities' attitudes towards women must be revealed and revised." Her work reveals why the literature of oppressed or "marginal" peoples is often so vital: oppression *per se* is not the source of creativity; rather it is the resistance to oppression which elicits "a willingness to reject convention and to hold on to what is difficult." In *Black Women Novelists: The Development of a Tradition, 1892–1976* (1980), Christian traces the evolution of black women from southern white literature's caricature of the black woman as Aunt Jemima, mammy, or concubine to early black novelists' view of her as the tragic mulatta (explaining the urgent sociopolitical agenda which fueled that depiction), and finally, to the rich diversity of visions of black women presented by contemporary black women writers.

Author of nearly one hundred essays and reviews, Christian also edited or co-edited several major critical texts, among them, *Female Subjects in Black and White: Race, Psychoanalysis, Feminism* (1997). One of her mostly widely read essays is "The Race for Theory," in which, affirming the centrality of literature over (increasingly arrogant) critical theory, she notes, "For me literature is a way of knowing that I am not hallucinating, that whatever I feel/know is. It is an affirmation that sensuality is intelligence, that sensual language is language that makes sense."

Barbara Christian was born in St. Thomas, Virgin Islands, in 1943. This photograph was taken during Christian's conversation with Alice Walker at KQED television studios in San Francisco in 1986.

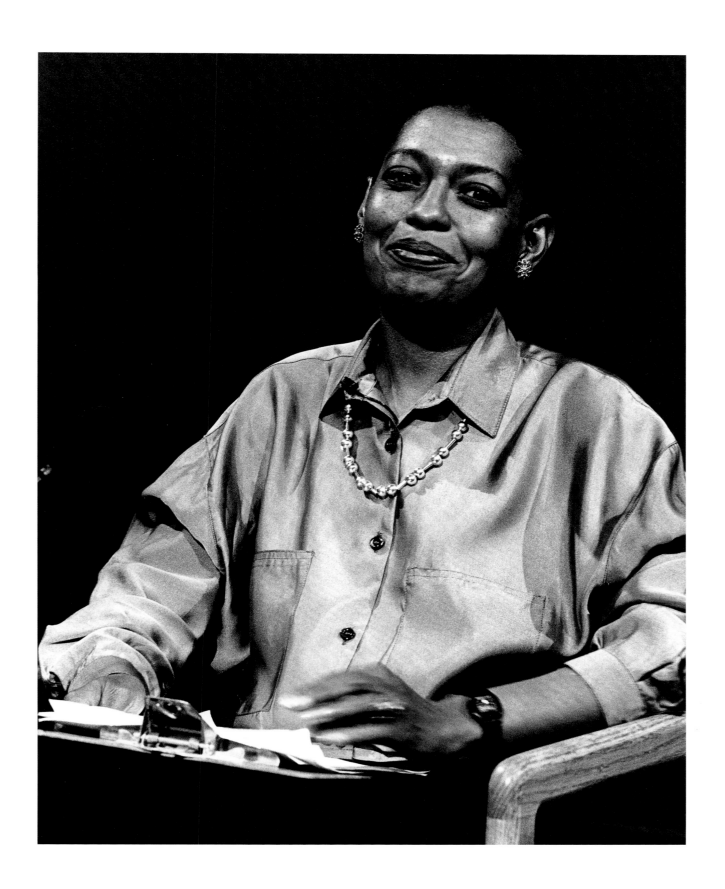

Cheryl Clarke

The power of lesbian community and female friendships undergirds virtually all of poet Cheryl Clarke's work. In her essay "Lesbianism: An Act of Resistance," Clarke delineates the lesbian who decolonizes her body as the center of her emotional, intellectual, and political life.

Narratives: Poems in the Tradition of Black Women (1982) assumes in its title the powerful legacy of black women's storytelling and slave narratives. Her poems are intended as speech acts of resistance, renaming a straightening comb a "sado-masochistic artifact / salvaged from some chamber of the Inquisition," and revealing without shame a Catholic girlhood in which "more than once an olive skinned nun pulled her / skirts up for me."

Clarke's poem "Of Althea and Flaxie" (*Narratives*) celebrates a nearly thirty-year-long span in the life of a lesbian couple and suggests the ways in which women's erotic autonomy empowered their ability to claim other forms of autonomy: of dress and work, as well as of resistance to the established codes of such institutions as welfare, jail, even funeral homes. Part of the power of the poem is that it dares to celebrate an explicitly butch-femme relationship—but not the stereotypical one. Althea, "very dark / very butch," is a welder who wears suits and ties, but also "love[s] to cook [and] sew." Her lover Flaxie may wear tight dresses and high heels, but "love[s] to shoot, fish, [and] play poker." Flaxie visits the imprisoned Althea weekly, "and hungered openly for her thru the bars / and did not give a damn who knew she waited for a woman."

Many of Clarke's poems explore a topic virtually silenced in traditional slave narratives: sexual and romantic love between black women in antebellum America. In "Sisters Part," *Humid Pitch: Narrative Poetry* (1989), Justina sternly urges Gatsey to flee the sexual predator who rules the plantation, offering an explanation, both chilling and understated, for her own failure to flee; her nights are so haunted by the ghosts of sexual violation that no psychic escape, and hence no freedom, will ever be possible: "Ain't leavin my ghosts. / You, ya ain't got that kind of comp'ny / yet."

"Epic of Song," a seventy-two-page poem, narrates the "long telling song" of Mourning Star Blue, abducted from her church choir to play in a most definitely secular traveling troupe, the Road Temple Eagle Rockers. Like a more randy version of Jewelle Gomez's lesbian love poem "Flamingoes and Bears," Clarke's sonnet "Tortoise and Badger," from her most recent volume *Experimental Love: Poetry* (1993), delights in the amorous coupling of two denizens of the animal kingdom: " . . . your shell is hardly cordial / and my spiky fur has gone seedy / . . . Want to turn you over to your soft belly, / silly, hungry me. You don't have much meat. / Just layers of sad and pleading, scaly / skin."

Born in Washington, D.C., in 1947, Cheryl Clarke is the director of the Office of Diverse Community Affairs and Lesbian-Gay Concerns at Rutgers University. Since 1985 she has also been an editor of the lesbian feminist journal *Conditions*. She is currently working on a new collection of poems, *Corridors of Nostalgia*. This photograph was taken at the Lesbian and Gay OutWrite Conference in San Francisco in 1991.

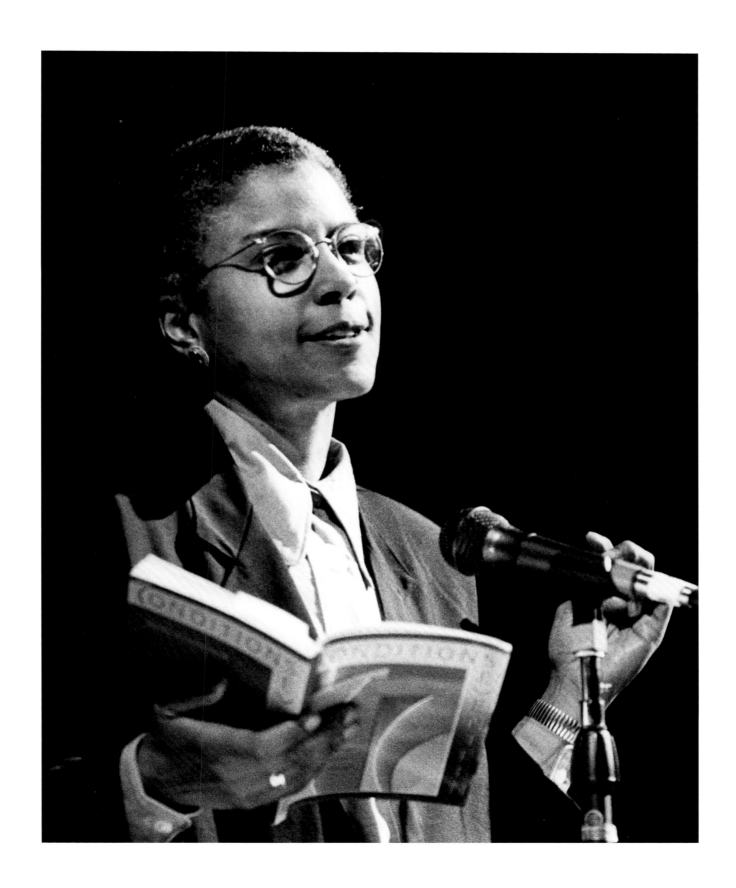

Lucille Clifton

Lucille Clifton's poetry is a craft of minimalism: quiet, spare, short, deceptively simple lines, with little punctuation or capitalization. Her poems, bone-deep and beautiful, glide effortlessly between present and past, reclaiming African history, storytelling, religion.

The poems in *Two-Headed Woman* (1980) trace the transformation in consciousness enabling black women to delight in their own physical beauty. In "homage to my hips," Clifton sings of her big hips that "have never been enslaved / . . . that go where they want to go / and . . . do what they want to do." In "homage to my hair," Clifton celebrates the nappiness of her hair as a source of erotic pleasure, while in "what the mirror said" Clifton draws a parallel between the physical terrain of the body—its "geography"—and the terrain of the psyche; knowledge and love of one leads to knowledge and love of the other. "To Merle" celebrates a patient, determined sisterhood that reaches back ten thousand years, playfully observing, "the last time I saw you was on the corner of / pyramid and sphinx," thus wryly providing modern city coordinates for an ancient location. Where sisterhood is unearned, Clifton also has an appropriately long memory. Announcing "I will have to forget / your face," she assigns a specifically unforgettable face to the legendary cruelty of plantation mistresses in "to Ms. Ann." Refusing to be paralyzed by grief, drawing upon the resolute tenacity and strength of generations of black women across the diaspora, Clifton celebrates in her poems the Edenic African past of Wydah as well as the simple survival of those "in the inner city / or / like we call it / home."

In *Generations: A Memoir* (1976) and in her poetry, she reaches back to actual and spiritual maternal ancestors, including Caroline, her West African great-great-grandmother, kidnapped from Dahomey, who at age eight, walked eight hundred miles from New Orleans to Virginia, and Lucille, Caroline's daughter and the ancestor for whom Clifton was named, who calmly "waited by the crossroads," shot the white father of her son, and, rifle in hand, was captured, tried, and hanged. Many of Clifton's poems are linguistic re-appropriations of biblical stories, placing Christian iconography in black contexts; in "Easter Sunday," she claims her own deity as a poet, insisting "I must slide down like a great dipper of stars / and lift men up."

Her poetry includes two Pulitzer Prize nominations: *Good Woman: Poems and a Memoir 1969–1980* (1987) and *Two-Headed Woman* (1980), as well as *Blessing the Boats: New and Selected Poems 1988–2000* (2000); *The Terrible Stories* (1996); *The Book of Light* (1993); *Quilting: Poems 1987–1990* (1991); *Next: New Poems* (1987); *An Ordinary Woman* (1974); *Good News About the Earth* (1972); and *Good Times* (1969). She has also written some twenty books for children, including the Everett Anderson series.

Born in Depew, New York, in 1936, former poet laureate for the state of Maryland and currently distinguished professor of humanities at St. Mary's College of Maryland, Lucille Clifton lives in Columbia, Maryland. This photograph was taken in 1985 at the University of California, Santa Cruz.

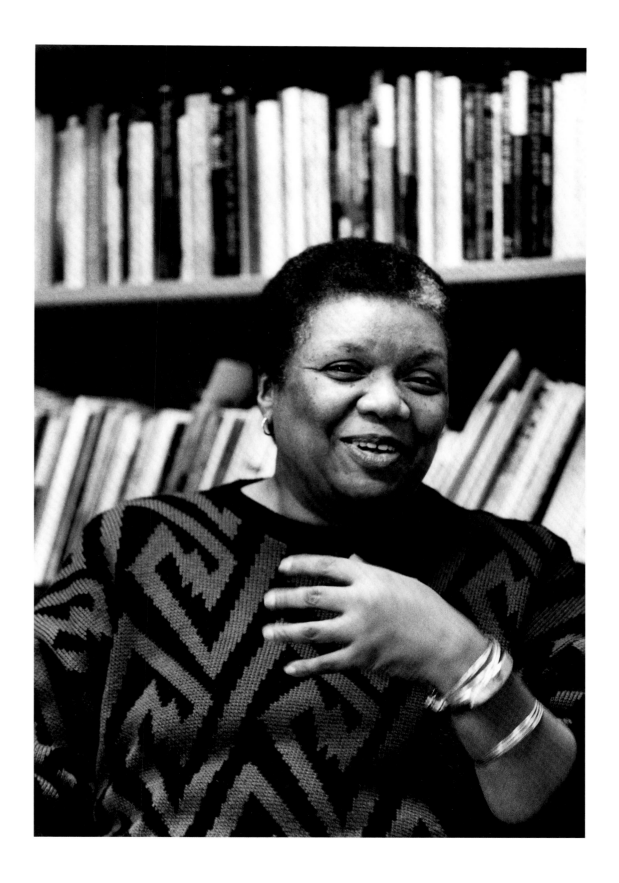

Wanda Coleman

Wanda Coleman's characters—the dignified, enraged inhabitants of an urban landscape pockmarked with violence, hopelessness, and despair—have been compared to those of Nathanael West, Ann Petry, Richard Wright, and Zora Neale Hurston. Personas from her earliest volume of poetry, *Mad Dog Black Lady* (1979), include a sexually abusive therapist, a prostitute, a medical billing clerk, a butch lesbian (who possessively announces to her fleeing bisexual lover: "to the grave . . . you be mine—you be my bitch"), and that metonym of white violence and the LAPD: a "wolf [who] has devoured most of my friends." The book's title comes from Coleman's perception of herself as "a mad dog of sorts," savagely attacked by racism, infected by a disease for which there is no known cure.

The title story of *A War of Eyes and Other Stories* (1988) explores racial fury and gender and class conflicts, borrowing its military metaphor from an experimental dance group exercise in which staring replaces more intimate modes of communication. Each of these stories, Coleman explains, "[has] to do with how one is visualized." The nine-part poem "South Central Los Angeles Deathtrip 1982" relentlessly enumerates the "causes of demise" for African Americans whose paths cross with the police, all detailed in an almost emotionless, atonal notation. But Coleman's generative offerings, wrested out of "this repetitive rendering of pain—for on my / one-palm island dwells no such beast as joy," engage our full intelligence. They sustain us as readers, much as the friendship between two women in "Where the Sun Don't Shine," "harbor[s] one another against the ferocity of living."

Most poems written about Emmett Till, for example, explore the brutality and violence done to a young black boy, his body battered beyond recognition for an alleged wolf whistle. The whistle itself is rarely mentioned. Coleman's "Emmett Till" *(African Sleeping Sickness,* 1990) *celebrates* this whistle, acknowledges its erotic joy as a treasure, and in so doing, forces readers to reexamine their own attitudes about sexuality and race. Coleman's Emmett "let go a whistle / a smooth long all american hallelujah whistle / appreciation. a boy / coming into manhood whistle. A ma'am / what I'd like to do some day to some woman look as good / as you do to me whistle."

Coleman's on-going American Sonnet series is perhaps her greatest accomplishment. In "American Sonnet #55—After Elinor Wylie," Coleman offers a grim urban alternate to the modernist poet's "austere immaculate . . . pearly monotones." The rhythm—although certainly not the theme—of this remarkably formal poem is borrowed from Wylie. It contains allusions to the Civil War, American hunger ("a nation's shelves ill-stocked"), the failed promise of reparations. Responding to Wylie's romanticism, Coleman's poem counters in its final lines with the molten fury that is her poetic trademark: "swift vengefulness like fire to the reeds / inflames my vigilant soul denies it rest."

Winner of the 1999 Lenore Marshall Poetry Prize for *Bathwater Wine* (1998), as well as recipient of Guggenheim and N.E.A. fellowships, Wanda Coleman, native of Los Angeles, was born in 1946. Her books include *Imagoes* (1983); *Heavy Daughter Blues: Poems and Stories 1968–1986* (1987); *Hand Dance* (1993); *Mambo Hips & Make Believe: A Novel* (1999); and *Mercurochrome: New Poems* (2001).

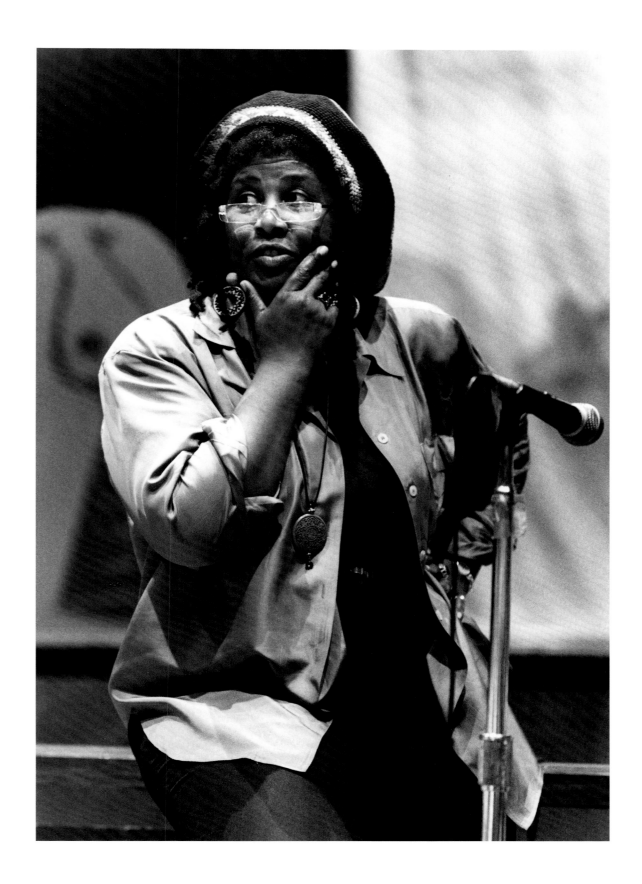

Edwidge Danticat

Lyric, fierce, resolute, chilling, compassionate, and wise beyond measure, the fiction of Edwidge Danticat brings to life the physical and political landscape of Haiti, the island she called home until the age of twelve. Danticat writes to reclaim history and national identity for Haiti, so often identified with the singular face of a male dictator. Against the backdrop of the story of soldiers, curfews, questioning, massacres, Danticat shares the hidden world of women, their songs, their stories, and their culture.

Her first novel, *Breath, Eyes, Memory* (1994), was her Brown University MFA thesis, a story of spirituality, love, and resistance, of three generations of women battling a culture of sexual, patriarchal, and political oppression. In a stunning reversal of the contempt Jamaica Kincaid's narrator in *Lucy* has towards the yellow daffodils that represent to her Wordsworth and British colonialism, Martine loves Haitian daffodils "because they grow in a place that they were not supposed to." Meant for colder climates, the daffodils are the color of pumpkin "as though they had acquired a bronze tinge from the skin of the natives who had adopted them."

Krik? Krak! (1995), a collection of nine interwoven short stories, was a finalist for the 1995 National Book Award. Juxtaposed to butterflies, banyon trees, mountains, and the memory of desire are murder, the military, sexual violence, and Haitians who flee death or imprisonment on a leaking boat with a bedsheet as its sail. Danticat describes hunger and deprivation so enormous that a piece of sky becomes a starving man's last meal. In "Seeing Things Simply," Princesse becomes Danticat's doppleganger; an artist with neither brushes nor paint, she claims the earth as her canvas, etches portraits in the dirt, and "watch[es] the stars line up in random battalions in the evening sky." *Krik? Krak!*'s "Epilogue" explains the writer's craft: "When you write, it's like braiding your hair. Taking a handful of coarse unruly strands and attempting to bring them unity."

Danticat's most recent novel, *The Farming of Bones* (1998), won the American Book Award. It recounts the story of Amabelle and many others fleeing from General Rafael Trujillo's 1937 massacre of 40,000 Haitians—his effort to racially "purify" the Dominican Republic. Like David Bradley's *The Chaneysville Incident*, Sherley Anne Williams's *Dessa Rose*, and Octavia Butler's *Parable of the Sower, The Farming of Bones* is fictional history, an exodus narrative—a story of flight and terror, mayhem and beauty. Danticat's description of mutilated humanity—workers missing cheekbones and fingers, the result of a machete gone awry—prefigures the bitter bone harvest to come. In the midst of all this horror, the memory of love flourishes in Amabelle, whose whispered narration of dreams and memories form a boldface counter text to the narrative of bare survival, of a people so poor they "take doors off hinges to make coffins for their dead": "His name is Sebastien Onius. Sometimes this is all I know. My back aches now in all those places that he claimed for himself, arches of bare skin that belonged to him, pockets where the flesh remains fragile, seared like unhealed burns where each falling scab uncovers a deeper wound."

Born in Port-au-Prince, Haiti, in 1969, Edwidge Danticat teaches creative writing at New York University. This photograph was taken in Berkeley in the fall of 1999.

28

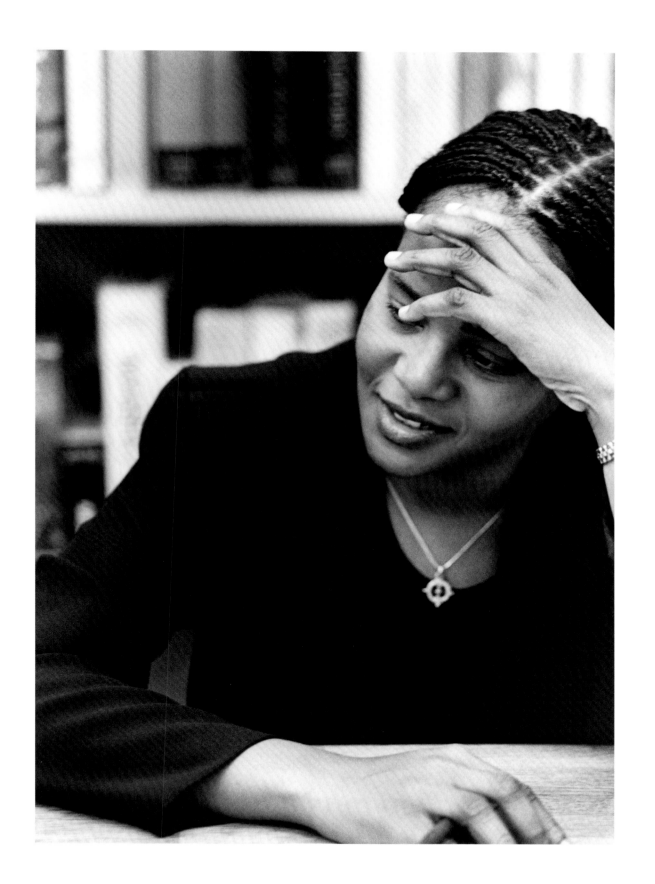

Angela Y. Davis

Angela Davis, cultural theorist, essayist, autobiographer, and the 1980 Communist Party candidate for vice president of the United States, is a scholar and a political activist, who has been fighting against economic and racial injustice since the 1960s. A member of the Communist party since 1968, Davis was fired from her position at the University of California in 1969 for her affiliation. In 1970, after being falsely implicated in a courthouse escape in Marin County, Davis was arrested for murder, kidnapping, and conspiracy. She was later acquitted of these charges, but the ordeal contributed to her activism on behalf of reforming the "prison industrial complex." The two weeks Davis spent evading police before her arrest inspired a kind of twentieth-century underground railroad for one: many thousands of homes and businesses across the country bloomed with signs reading, "Angela, sister, you are welcome in this house."

Released from prison after sixteen months, Davis published essays in a collection entitled *If They Come in the Morning: Voices of Resistance* (1971). Her essays offer a Marxist analysis of racial oppression in America and argue persuasively that the long-term ramifications of freeing political prisoners "transcend its immediate objective to free specific individuals," noting that the struggle to free the "Scottsboro Boys" resulted in Supreme Court decisions requiring that indigent defendants be provided with free legal representation in capital cases and that blacks not be barred from jury duty. In "Lessons: From Attica to Soledad" Davis remarks upon the ways in which liberation struggles inside prison mirror those outside and praises what she terms "a conscious thrust among many prison populations towards new and arduously wrought collective life." Her essay "Reflections on the Black Woman's Role in the Commu-

nity of Slaves" (1971) reveals the story of a courageous pregnant black woman, chained to other slaves on a coffle, who helped lead an uprising. This essay provided Sherley Anne Williams with the incident that inspired the neo slave narrative novel *Dessa Rose*.

Angela Davis: An Autobiography (1974), explores in detail Davis's commitment to communism, while her 1981 collection of essays, *Women, Race, and Class*, discusses the conditions of slavery for women and cites the courageous and infuriated words of Margaret Garner (the historical figure who inspired Toni Morrison's *Beloved*): "I will go singing to the gallows rather than be returned to slavery." Indicting Stowe's *Uncle Tom's Cabin* for "miserably fail[ing] to capture the reality and the truth of black women's resistance to slavery," Davis also indicts contemporary white feminists for their own occluded vision. In "Rape, Racism, and the Myth of the Black Rapist," she focuses attention on Susan Brownmiller's racist misreading of Emmett Till's alleged wolf whistle at a white woman.

Davis is also the author of *Women, Culture, and Politics* (1989), a collection of her speeches, and *Blues Legacies and Black Feminism: Ma Rainey, Bessie Smith, and Billie Holiday* (1998), a text that interpreted "the work of these three prominent performing artists of the African American past as helping to forge other legacies—blues legacies, black working-class legacies, of feminism."

Angela Davis, born in Birmingham, Alabama, in 1944, is a professor at the University of California at Santa Cruz. This photograph was taken in April 1989 at Mills College, Oakland.

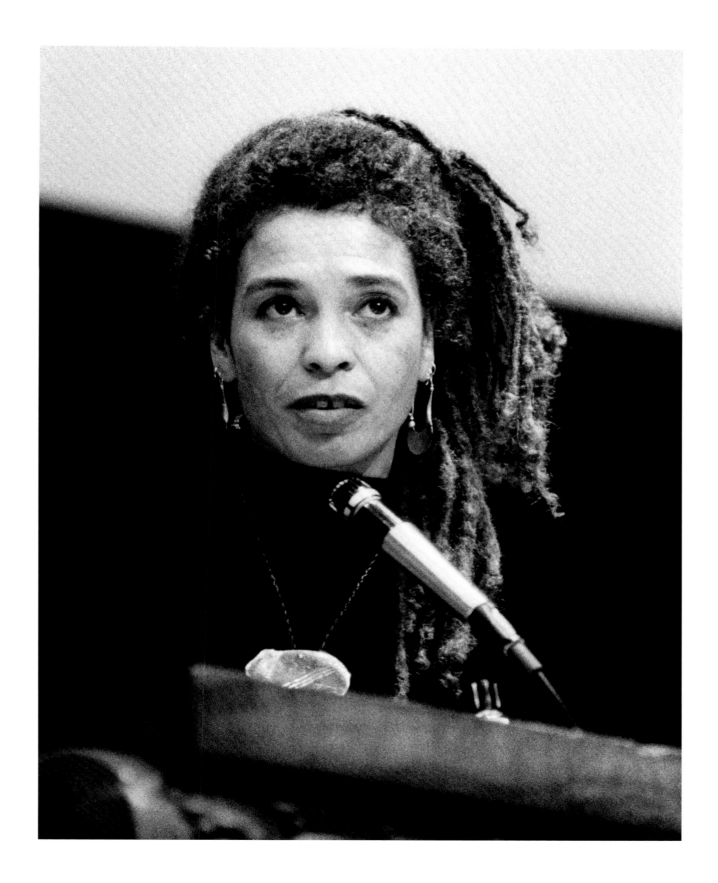

Samuel R. Delany

Prolific, playful, witty, and erudite, Samuel R. Delany has consistently refused to valorize literature over speculative fiction, defining "genre" simply as "a protocol of reading." A writer of enormous range, depth, and stylistic vividness, he has written more than twenty novels (science fiction, pornography, and sword-and-sorcery fantasy), prize-winning science fiction short stories, and a dozen books of nonfiction including criticism, memoirs, correspondence, and interviews.

Delany's life and writings are attuned to the postmodernist challenges to mainstream thought posed by the late twentieth-century intellectual and artistic avant-garde. "The constant and insistent experience I have had as a black man, as a gay man, as a science fiction writer in racist, sexist, homophobic America, with its carefully maintained tradition of high art and low, colors and contours every sentence I write," he states in a 1986 interview. His response has been to question the status quo whenever possible, creating, for example, innovative fiction in which dark complexion marks the ruling class, while the underclass is blond and blue-eyed. Science fiction, he suggests, allows him to examine how "beings with a different social organization, environment . . . and body [might] perceive things." His interest in the power of language to determine ideas—and thus culture—fuels his early novel *Babel-17* (1966), which explores the discovery of an intricate, alien language during intergalactic wartime and cryptographer Rydra Wong's quest to discover its meanings.

The 1975 publication of *Dhalgren* announced the arrival of Delany as a major writer who set himself the task of discussing race, language, mythology, sexuality, slavery, and gender in works that invite the reader to become the co-creator of shifting worlds. In *Stars in My Pocket Like Grains of Sand* (1984) Delany's idiosyncratic style and matter-of-fact references to imaginary planets force the reader to participate actively in the reading experience: "—what I saw was not the cities blasted into the shadowy wall of the canyons that worm the polar plates of Zetzor (its equatorial regions clotted with lichen jungles, fused deserts, and fuming bismuth swamps that make the –wrs of Velm seem like ancient carburetor leakings); what I envisioned was a scape of silicate sand, airs darkened to dim gold by dusts too hot to bear; and through kilometer after kilometer of umbrial dunes, the only irregularity beyond the grit rush was one shadow, barely human, stalking away."

Deeply interested in genre cross-fertilization, Delany continually explores new terrain, even when writing about his fascination with porn theaters. His *Times Square Red, Times Square Blue* (1999) is a compelling individual memoir, but it is also the social autobiography of a city. Delany's eclectic list of writings includes *Tides of Lust* (1973); science fiction novels *The Einstein Intersection* (1967), *Triton* (1976), and the *Return of Nevèrÿon* series (1979–1987); a 1977 collection of critical essays, *The Jewel-Hinged Jaw*; and the autobiographical *Motion of Light in Water* (1988). His science fiction has won both Hugo and Nebula awards.

Born in New York City in 1942, Samuel "Chip" Delany currently teaches at Temple University. This photograph was taken at the writer's home in New York City in June 2000.

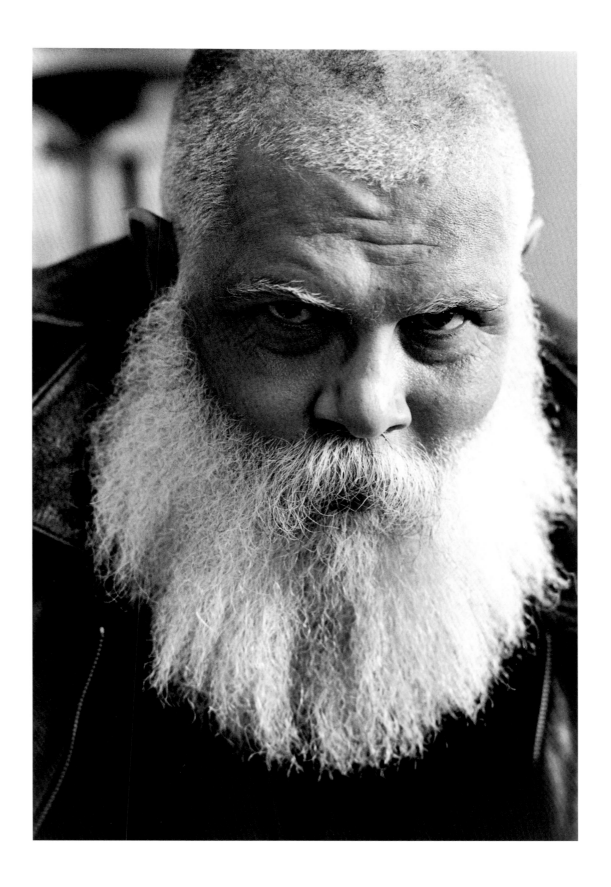

Toi Derricotte

"The worst is true," poet Toi Derricotte acknowledges in "A Note on My Son's Face": "Everything you did not want to know." There is an overwhelming sense of danger in poems like "On the Turning Up of Unidentified Black Female Corpses" and "Aerial Photography before the Atomic Bomb," poems that link public and historical violence with malevolence and destructiveness closer to home.

Derricotte drives the confessional poem to almost unspeakably painful realms: "Dead Baby Speaks" describes a mother guilty of emotional incest "who wanted my soul for company . . . / who brought me up to the surface by straining off the rich dark broth" of the child's wholeness. In "Touching/Not Touching: My Mother," Derricotte explores her own complex responses to the totem power of her mother's suffocating love. While "Poem for My Father" (*Captivity*, 1989) and "When My Father Was Beating Me" (*Tender*, 1997) depict physical abuse, the family home becomes a literal slaughterhouse in the title poem from *Tender*: "The tenderest meat / comes from the houses / where you hear the least / squealing. The secret / is to give a little / wine before killing."

Derricotte interrogates race ("'black' is not a color, it is a / blazing skin"), the shame and pain of unwed childbirthing (*Natural Birth*, 1983), and marital failure ("Saturday Night"). In the latter, the dark landscape of the couple's separation from one another is searingly illuminated by a meteorological simile: "We are packed in a frame bed like a child's wagon in the / middle of a tornado." Poems such as "The Weakness," "Family Secrets," and "Workshop on Racism" present the poet's hard-won lessons on race, in a language chiseled by cold anger.

Some of Derricotte's most powerful and resonant prose issues from the straddling of the color line, from the inner arguments and questions she has faced as a "white-appearing Black person." In "Passing," she confounds a female student who assumes she's white: "Why presume / 'passing' is based on what I leave out / and not what she fills in?" *The Black Notebooks* (1997), a deeply courageous collection of meditations on race, had its origins in a journal Derricotte kept during a bout with depression. She records the language of self-hatred, shame, internalized colorism, rage, sadness, the need to "bear and bare anger," to confront her own complicity and denial. And finally, movingly, she records the process of enacting self-forgiveness.

Creating poems that are "houses for the heart to live in," Derricotte celebrates sexual desire ("Clitoris") and spiritual connection to such literary ancestors as Sonia Sanchez ("I / hold you tender. Our / life is short. / We've chosen / who we love") and Pat Parker ("a hardness with a trembling at its center"). The epigram to her Elmira Castle poems describes the branding of slaves "burnt with red hot iron." Derricotte's poems do exactly that: they rend the flesh and leave us marked forever.

Toi Derricotte was born in 1941 in Detroit, Michigan. Author of *The Empress of the Death House* (1978), recipient of two National Endowment for the Arts fellowships, she is also the cofounder of Cave Canem, a workshop retreat for African American poets. Derricotte is currently a professor of English at the University of Pittsburgh. This photograph was taken in San Francisco in July 2000.

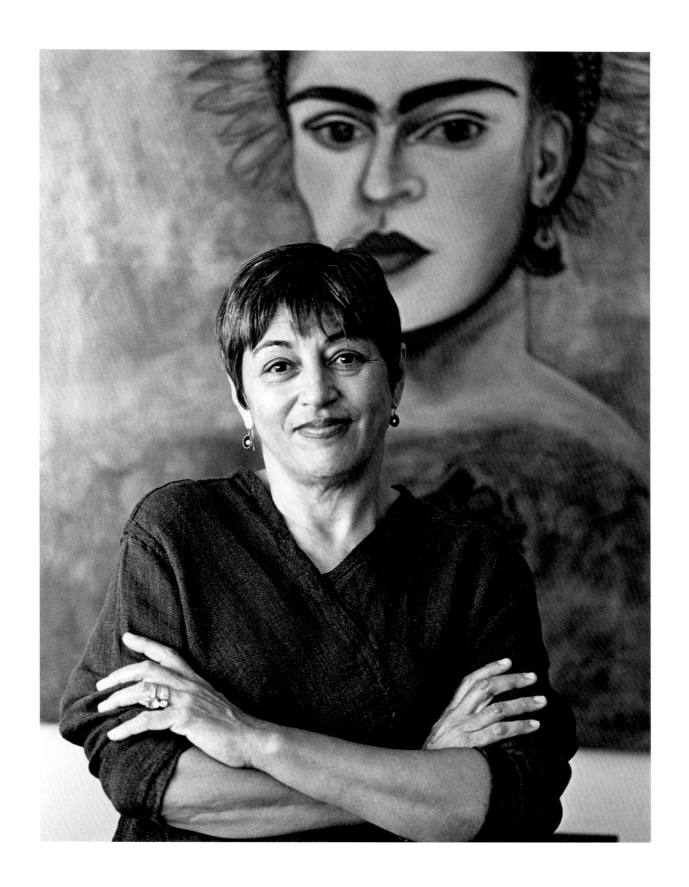

Rita Dove

Rita Dove's subtle, elegant, disciplined poems reflect a dazzling range of intellectual curiosities and emotional timbres. Dove gets the details right—in an often mercilessly wry, colloquial, and insightful way: a mother's excruciatingly painful lunch with her distanced daughter in "The Bistro Styx" (*Mother Love*, 1995), or the slang expression "now you're cooking," juxtaposed to the implied image of heroin cooking on a "magic spoon" in "Canary." In "Götterdämmerung" (*On the Bus with Rosa Parks*, 1999), the narrator, defying the association of a woman's aging with asexuality and declining physical and imaginative powers, announces, "I've never / stopped wanting to cross / the equator, /or touch an elk's / horns, or sing *Tosca* or screw / James Dean in a field of wheat. . . . / I'll never be through with my life."

In her poetry, Dove often addresses the writer's craft. For instance, "Reading Hölderlin on the Patio with the Aid of a Dictionary" speaks of inspiration: "The meaning that surfaces / comes to me aslant and / I go to meet it." "The Fish in the Stone" addresses language; inscribing oneself in stone is a pleasure that belongs to the writer as well as the fish becoming a fossil, as each "drifts / until the moment comes / to cast his / skeletal blossom."

Dove's poems imaginatively embrace the experiences of the "other." While breastfeeding her daughter, the speaker in "Pastoral" experiences "what a young man must feel / with his first love asleep on his breast: / desire, and the freedom to imagine it." "The Transport of Slaves from Maryland to Mississippi" (*The Yellow House on the Corner*, 1980) details an insurrection from the vantage-point of a slave woman who foils the escape. Even dictator Rafael Trujillo—slaughterer of forty thousand Haitian caneworkers in the Dominican Republic

and the subject of Dove's poem "Parsley" (*Museum*, 1983)—is not simply a villain, but a demented, unmended wound. "What goes through Trujillo's mind as he tries to find a way to kill someone," Dove explains, "is my own invention. . . . Making us get into his head may shock us all into seeing what the human being is capable of."

The Pulitzer Prize–winning *Thomas and Beulah* (1986), based loosely on Dove's maternal grandparents, records the ordinary moments of their lives, as first one and then the other relate individual versions of their years together. Dove describes these poems as "a parody on history because private dates are put on equal footing with dates of publicly important happenings. But significant events in the private sphere are rarely written up in history books, although they make up the life-sustaining fabric of humanity." When Thomas's friend Lem drowns on Thomas's drunken dare, he leaves behind only a mandolin and Thomas's lifelong, keening sorrow.

Dove's other books include *Grace Notes* (1989), *Selected Poems* (1993), the short story collection *Fifth Sunday* (1985), *Through the Ivory Gate: A Novel* (1992), and *The Darker Face of the Earth: A Verse Play* (1994). Born in Akron, Ohio, in 1952, Rita Dove now teaches at the University of Virginia. She was appointed Poet Laureate of the United States from 1993 to 1995 and is the recipient of numerous other honors, including a Guggenheim, a Mellon, and a Fulbright. This photograph was taken at the Library of Congress, Washington, D.C., in April 2000.

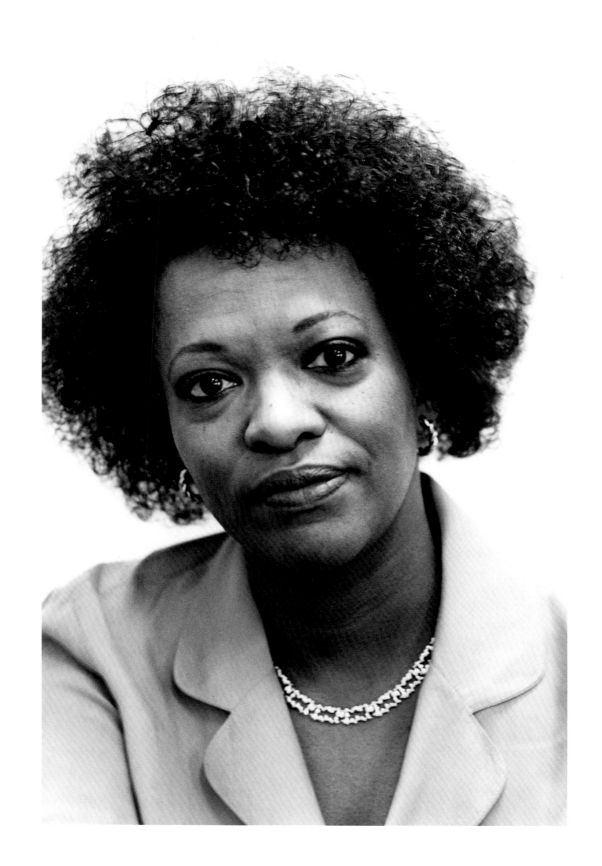

Frances Smith Foster

Scholar Frances Smith Foster's *Witnessing Slavery: The Development of Antebellum Slave Narratives* (1979) was one of the first critical studies to examine slave narratives as an important literary genre, and more than twenty years later, it continues to be among the most significant contributions to our understanding of this era in African American literature. Foster delineated the debt that early African American fiction owes to the slave narrative—not only in terms of thematics and characterization, but also in points of view, structure, diction, irony, humor, understatement, melodrama as narrative strategy, and the creation of "The Heroic Slave" as protagonist.

Her subsequent study, *Written by Herself: Literary Production by African American Women, 1746–1892* (1993), established indisputably the existence of a rich intertextual tradition of African American women's writing, one that existed for at least a century and a half before most contemporary critics have acknowledged that such a tradition began. Asserting that "black women have a strong claim to being considered the founders of both the African American literary tradition and the American women's literary tradition," Foster also refutes those critics who have condemned early African American writing as capitulations to white audiences, pointing out that African American women (and African American men as well) "appropriated the English literary tradition to reveal, to interpret, to challenge, and to change perceptions of themselves and the world in which they found themselves." This carefully reasoned argument that the disenfranchised used the tools of the master to dismantle the master's house encourages vibrant and subversive new readings of such texts as the poems of

Phillis Wheatley, Frances Harper, and Lucy Terry. Exploring an ancestral tradition of talking and testifying, the use of language as both a tool and a weapon, Foster's work reveals the way in which African American writers generally, and African American women writers in particular, have actively sought out their literary precursors, whose very existence is not a quasi-oedipal threat, but rather an affirmation of their own existence in a literary tradition which has revolted against and subverted white, patriarchal literary authority.

Born in Dayton, Ohio, in 1944, Foster is the editor of *A Brighter Coming Day: A Frances Ellen Watkins Harper Reader* (1990) and *Minnie's Sacrifice, Sowing and Reaping, Trial and Triumph: Three Rediscovered Novels by Frances Ellen Watkins Harper* (1994). Co-editor of both *The Norton Anthology of African American Literature* (1996) and the *Oxford Companion to African American Literature* (1997), Frances Smith Foster has taught at both San Diego State University and University of California, San Diego (where she received her Ph.D.), and is currently Charles Howard Candler Professor of English and Women's Studies at Emory University. This photograph was taken at Fran Foster's home in La Mesa, a suburb of San Diego, in 1990.

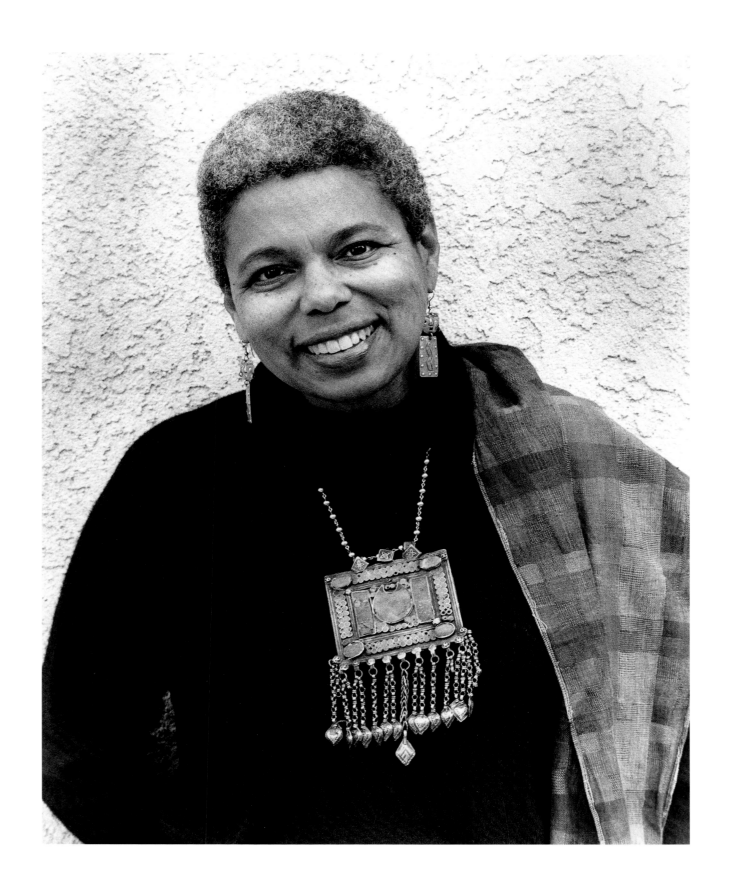

Ernest J. Gaines

A master of voice in his fiction, Ernest Gaines comments, "Usually, once I develop a character and hear his voice, I can let him tell the story." Of his characters' Louisiana dialect—"that combination of English, Creole, Cajun, Black"—Gaines adds, "For me, there's no more beautiful sound anywhere." *A Gathering of Old Men* (1983), a novel about resistance and community, has fifteen narrators, most of them elderly black men, and not one sounds like any other. The accuracy of the title character's idiom in *The Autobiography of Miss Jane Pittman* (1971), modeled after that of his Aunt Augusteen Jefferson, led many readers and reviewers to mistake Miss Jane for a real person.

Raised by his aunt, who was so disabled she could only crawl to get around the house, Gaines dedicated *Autobiography* to this courageous woman, "who did not walk a day in her life but who taught me the importance of standing." Truth-telling is both poignant and pointed in this historical novel that records Jane's life from slavery to the civil rights era. For instance, the plantation mistress who regretfully warns Jane, "there ain't no Ohio," speaks the truth, for there is no magical "North" that Jane can count on to offer a sufficient departure from oppressive racial belief systems typical of the rural South. The eleven-year-old Jane conveys an existential truth when she tartly responds to the insults of a nasty black overseer: "If I ain't nothing but trouble, you ain't nothing but Nothing."

Gaines's fiction, arising from a profoundly moral vision, extols the daunting heroism of ordinary people. As Gordon Thompson observes, "[Gaines] writes about the small-minded and misguided only if he can love them; and of the big-hearted and the patient, he composes portraits of a love so boundless that even as he describes inexcusably inhumane situations, his prose remains unequivocally serene."

In *A Lesson Before Dying* (1993), Gaines offers a window into the lives of African Americans in the pre–Civil Rights South. Set in 1948, the book follows schoolteacher Grant Wiggins as he visits Jefferson, an innocent man awaiting execution. In an allusion to Claude McKay's poem "If We Must Die" ("If we must die, let it not be like hogs / Hunted and penned in an inglorious spot . . . "), the unlettered Jefferson—described as a "hog" by his white defense lawyer—teaches Grant a lesson about dignity, courage, manhood: *"If I ain't nothing but a hog, how come they don't knock me in the head like a hog? Starb me like a hog? . . . Man walk on two foots; hogs on four hoofs."*

Born in 1933 on the River Lake plantation in Point Coupée Parish, Louisiana, the rural setting for the fictional town of Bayonne, Gaines is the author of *Bloodline* (1968), a collection of short stories, including the much acclaimed "The Sky Is Gray," and the novels *Catherine Carmier* (1964), *Of Love and Dust* (1967) (inspired by the Lightnin' Hopkins blues song, "Mr. Tim Moore's Farm"), and *In My Father's House* (1978). The recipient of MacArthur, NEA, and Guggenheim Fellowships, Ernest Gaines teaches at the University of Louisiana at Lafayette. This photograph was taken in Berkeley in 1994.

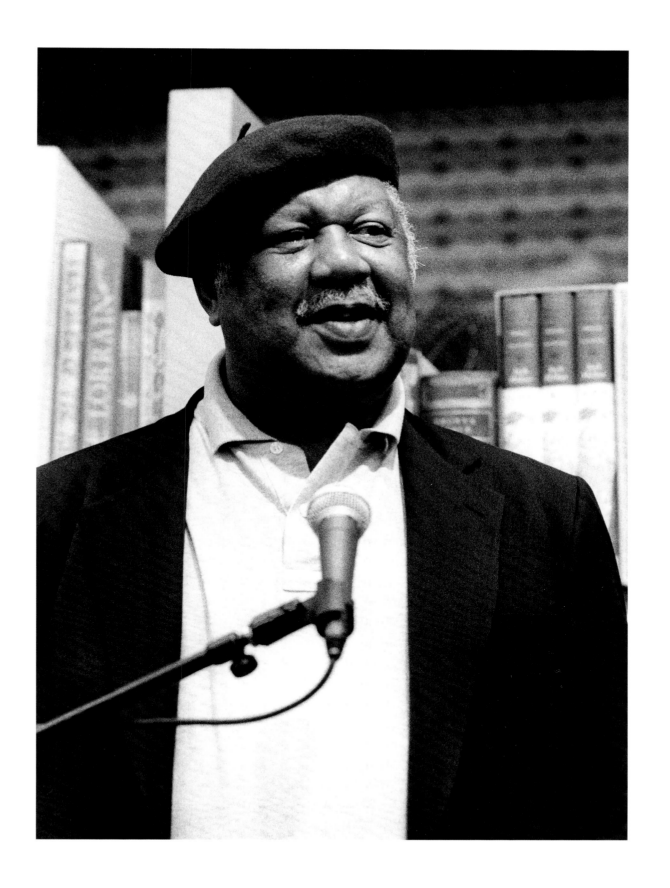

Henry Louis Gates, Jr.

"If you want to change the world," Henry Louis Gates, Jr., said in a 1998 interview, "you don't think of getting a Ph.D. in English as the most direct route to doing that." Yet Gates has moved smoothly and with great panache from an early-achieved pinnacle of academic success to a nationwide forum that includes influential journalism, opinion pieces, and two television series created for the Public Broadcasting Service.

Early in his career, Gates began anchoring black literary criticism explicitly in West African traditions of interpretation and fighting against a reductionist approach that imprisons African American texts within sociological frameworks of negation or assertion. "[U]ltimately our subject is literary discourse, and not the blackness of blackness." The culmination of this effort, a major revision and reordering of the African American canon, was *The Signifying Monkey: Towards a Theory of Afro-American Literary Criticism* (1988), winner of a 1989 American Book Award.

From his position at Harvard University as chair of the Department of Afro-American Studies and director of the Du Bois Institute for Afro-American Research, Gates has used his bully pulpit to preach a complex and entertaining message of tolerance and civic obligation laced with judicious use of black expression. His popular style blends wit, erudition, and hipness into a wry appreciation of the American racial comedy that tries unsuccessfully to define who the black person is. Here, for example, are his reflections, first published in *The New Yorker*, on the criminal trial of O. J. Simpson: "[T]he trial provides a fitting rejoinder to those who claim that we live in an utterly fragmented culture, bereft of the common narratives that bind a people together. True, Parson Weems has given way to Dan Rather, but public narrative persists. Nor has it escaped notice that the biggest televised legal contests of the last half decade have involved race matters: Anita Hill and Rodney King. So there you have it: the Simpson trial—black entertainment at its finest. Ralph Ellison's hopeful insistence on the Negro's centrality to American culture finds, at last, a certain tawdry confirmation."

Gates has also made major contributions to African American studies as editor and co-editor of numerous volumes of essays (*Black Literature and Literary Theory*, 1984), reprints (*The Classic Slave Narratives*, 1987), and anthologies (*The Norton Anthology of African American Literature*, 1996). When asked what he would like his impact on culture and politics to be, Gates replied, "First and last point of reference is the creation of a great center of African American Studies."

Henry Louis Gates, Jr. (also known as "Skip") was born in Keyser, West Virginia in 1950. He is the author of *Figures in Black* (1987), *Colored People: A Memoir* (1994), and *Thirteen Ways of Looking at a Black Man*, a collection of his *New Yorker* pieces. Gates was also the 1991 recipient of a MacArthur Fellowship. This photograph was taken in Berkeley in 1995.

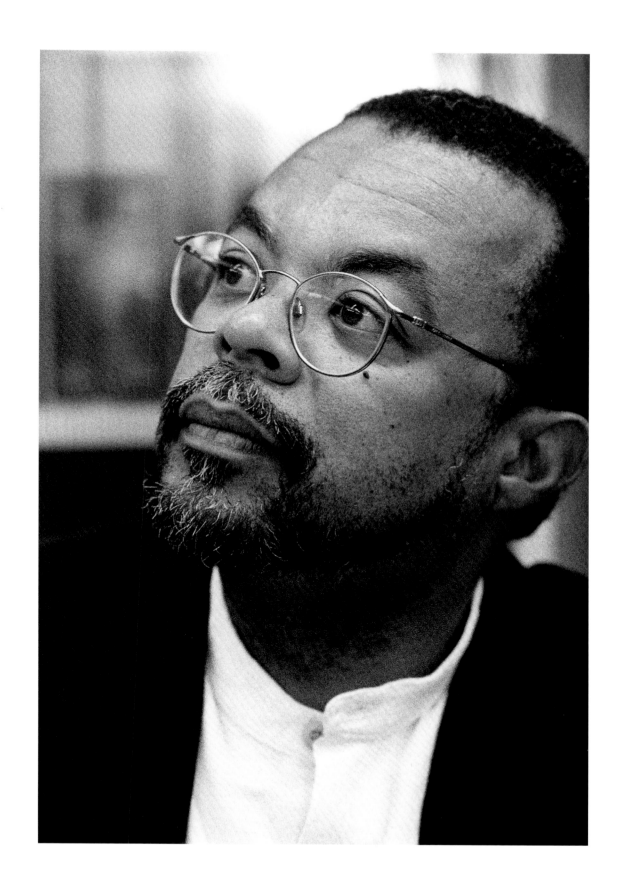

Nikki Giovanni

Poet Nikki Giovanni may be the most widely read living poet in America; she certainly is among the most controversial. Some of her early poems seemed more like Molotov cocktails than poems. Whether the invocation to mayhem in her first three poetry publications—*Black Feeling/Black Talk* (1968), *Black Judgement* (1968), *Re: Creation* (1970)—was meant literally, the most revolutionary aspect of these poems was a demand that black people exterminate in themselves any impulse to passivity or capitulation: from "A Litany for Peppe": "Blessed be machine guns in Black hands"; from "For Saundra": "maybe I shouldn't write / at all / but clean my gun / and check my kerosene supply"; and from "The True Import of Present Dialogue, Black vs Negro": "Nigger / Can you kill / Can you kill the nigger / in you."

The much-anthologized "Nikki-Rosa" celebrated the majesty of black family life, while the joyous eroticism of "Beautiful Black Men" in their "fire red, lime green, burnt orange / royal blue tight pants that hug / what I like to hug" signaled a death-knell to depictions of prim and tragic mulattas.

In *Gemini: An Extended Autobiographical Statement on My First Twenty-five Years of Being a Black Poet* (1971), Giovanni writes with powerful lyricism about black men and their ancestors, their grief, their anger, and their vulnerability. Resisting what she considered to be the ideological prescriptiveness of the Black Arts Movement, she chose in later books, like *My House* (1972), *The Women and the Men* (1975), *Cotton Candy on a Rainy Day* (1978), and *Those Who Ride the Night Winds* (1983), to include more personal themes: loneliness, isolation, disillusionment, friendship, family life, ancestors, heroes, hope. Of her apparent unconcern with the formal devices of poetry, Giovanni explains that she doesn't often revise, because she sees poetry as "a way of capturing a moment . . . a single stroke."

In her interview with Claudia Tate, Giovanni celebrates mythic black women, asking us to imagine what "a slave ship must have sounded like to a woman. The humming must have been deafening. . . . The hum, the gospel, the call-and-response came over because it's here. The men didn't bring it over. . . . They didn't bring the hum; they didn't bring the leader-call; they didn't bring the field hollers, because they didn't know them. . . . They were hunters. Hunters don't make noise. So what we're hearing in the music is the women. . . ."

Born Yolande Cornelia Giovanni, Jr., in 1943 in Knoxville, Tennessee, Nikki Giovanni is currently a professor of English at Virginia Polytechnic Institute. Her many publications include *Selected Poems* (1996), several volumes of poetry for children, recorded poems with a gospel choir: *Truth Is on Its Way* (1971), *The Way I Feel* (1975), as well as dialogues with James Baldwin (1973) and Margaret Walker *(*1974) and the essay collections, *Sacred Cows . . . And Other Edibles* (1988), and *Racism 101* (1994). She is currently working on a book about surviving lung cancer. This photograph was taken in Northern California circa 1980.

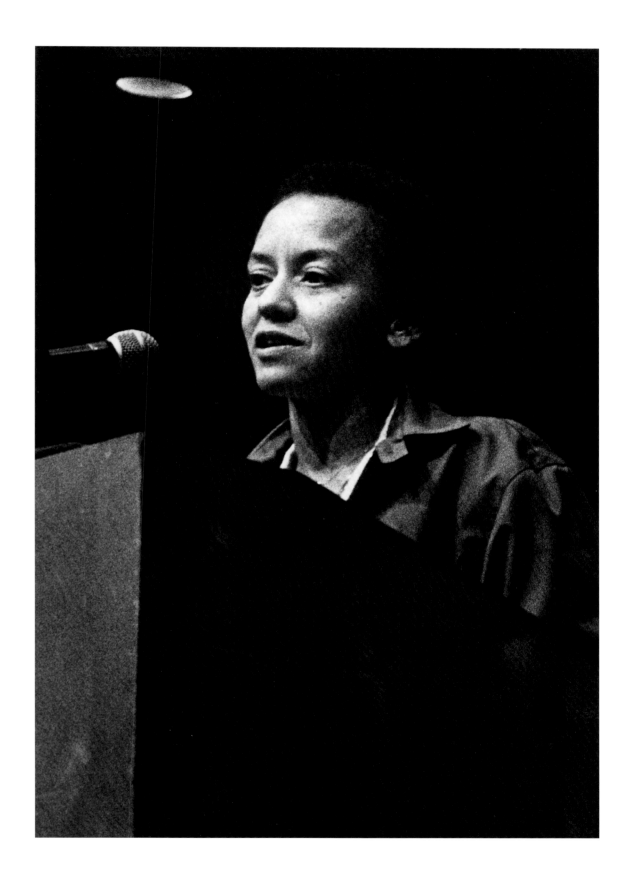

Jewelle Gomez

Jewelle Gomez's most well-known literary production, *The Gilda Stories: A Novel* (1991), a double Lambda award-winner, is a rich and complex gumbo of science fiction, historical romance, vampire story, and picaresque novel. Gilda, a young woman fleeing slavery in Louisiana, lives through two centuries of telling historical moments, including the internalized colorism that privileges "creamy-colored quadroons" over their darker sisters in antebellum New Orleans, and the prison rebellion in Attica ("she'd seen the pictures of inmates killing and being killed, lined up in the prison yard, and the image was always the same as her memories of the slave quarters: dark men with eyes full of submission and rage"), as well as an apocalyptic twenty-first century ecological tragedy. This genre-stretching, remarkable work explores the notion of profound spiritual reciprocity, of friendship and love across gender, generation, class, and race; the power of female sexual desire; and the liberating possibilities of a multitude of sexually transgressive taboos. Most of all, it imaginatively reconstructs the concept of how "one takes on others as family and continually reshapes that meaning," with the lesbian/gay ethos of chosen family, and the idea of African American community as family implicit in the vampire family that Gilda embraces.

Gomez is the author of three collections of poetry, including *The Lipstick Papers* (1980) and *Flamingoes and Bears* (1986), whose title poem joyfully celebrates (in a meter that seems like a delightful riff on Dr. Seuss) the rightness of the odd coupling of flamingo and bear, who "sleep forever entwined / in all sorts of climes." The title poem of her most recent collection, *Oral Tradition: Selected Poems Old and New* (1995) is not only a tribute to African American literature and culture, but a pun on lesbian lovemaking. Some of the most moving poems in this collection are subtle, beautiful, understated performance pieces from Gomez's play *Bones & Ash: A Gilda Story*. Gilda's "Songs" interrogate the experience of slavery ("Rest, which is for them. / Sleep, which is for us"), sexuality ("when my mouth is open to let ideas out and you in, / that is desire") and female power ("I am not a woman ripe for splitting open / but a tightly wrapped package of everything we need to know"). In *Forty-Three Septembers: Essays* (1993), she infuses the personal essay with an acute political awareness, describing "coming out" for black lesbians and gay men as having striking parallels with slave narratives, in that it is "usually a tale of triumph over repressive conditions in which the narrator emerges with a stronger, more positive identity."

Born in Boston in 1948 and now living in San Francisco, Jewelle Gomez has directed the Literature Program of the New York State Council on the Arts as well as the Poetry Center and American Poetry Archives at San Francisco State University. She is currently at work on a comic novel about 1960s black activists facing middle age and a collaborative performance piece based on the life of James Baldwin. This photograph was taken in 1986 in San Francisco during A Different Light Bookstore Readers and Writers conference.

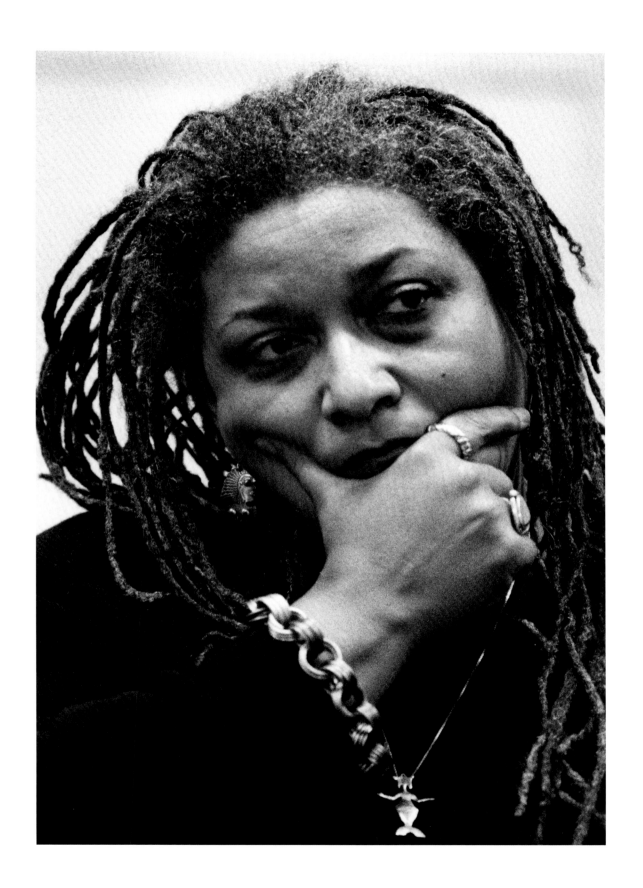

Rosa Guy

In a world so often defined by difference, novelist Rosa Guy's characters search for geographic and spiritual safe harbor: for someone who has shared their experience, for some place familiar that they can call home. In Guy's most recent novel, *The Sun, the Sea, a Touch of the Wind* (1995), Jonnie Dash, a successful painter, travels from New York to Haiti in an attempt to find solace and healing following the death of her son. She finds herself constantly reaching out to her own reflection in other people, only to find that in her homeland, a place she felt she ought to belong by virtue of race and heritage, she is viewed as an outsider, as "the pale American." An orphaned expatriate Harlem artist, Jonnie in many respects mirrors Guy, an expatriate who immigrated with her family from Trinidad to Harlem. She herself was orphaned at twelve, left school for factory work at fourteen, and married at sixteen.

In 1951 Rosa Guy and John Oliver Killens were the primary founders of the Harlem Writer's Guild, whose participants included Maya Angelou, Audre Lorde, Paule Marshall, and Douglas Turner Ward. Responding to the social upheaval of the 1960s, Guy decided that the voices of young black people needed to be heard as the authors of their own autobiographical works. She collected, edited, and published such an anthology: *Children of Longing* (1970).

Guy's first novel, *Bird at My Window* (1966), set in a Harlem full of racism and rage, violence and shattered dreams, recounts the dark narrative of Wade Williams, a man constantly confronted with familial and social rejection that inscribes in him a bitterness he is unable to overcome. *The Friends* (1973), winner of the American Library Association Notable Book Award, explores Phylissia Cathy's struggle to overcome the legacy of internalized colorism and class arrogance she inherits from her West Indian father. In *Ruby* (1976), Guy's most controversial novel, the title character finds comfort, safety, and romantic love in her relationship with her closest friend Daphne.

As much as the heroine, Dorine Davis, Harlem itself is a protagonist in *A Measure of Time* (1983), observed and eulogized, its "warped and twisted soul" exposed and lamented. Readers see glimpses of nascent social and political awareness in Dorine; she muses admiringly about famed black revolutionary Marcus Garvey "demanding something he called dignity for his people," and, in the wake of the Scottsboro Boys incident, observes that "when a black feller got cut in Alabama, folks in Harlem bled." Yet Dorine remains remarkably solipsistic; her response to hearing about Rosa Park's refusal to give up her seat on the bus, an event that sparked the Montgomery bus boycott, is viewed by Dorine only for its possible personal inconvenience: "after all these hundreds of years, a fool woman sits in the front of a bus in Montgomery and it's about to mess the hell outa my life."

Rosa Guy was born in 1925. She is the author of numerous children's books including a translation of Birago Diop's *Mother Crocodile: An Amadou Tale from Senegal* (1981). This photograph was taken in northern California in 1995.

48

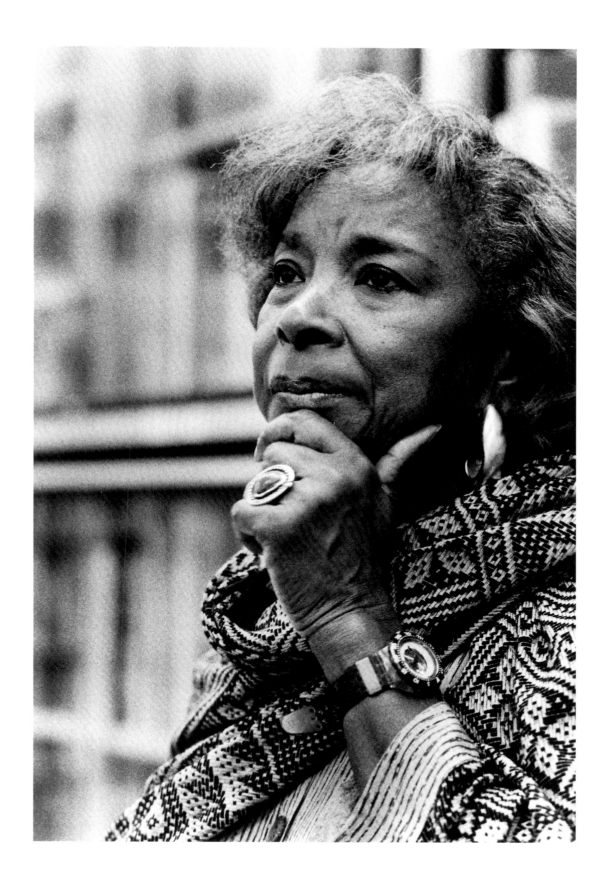

Forrest Hamer

Forrest Hamer's poetic voice is confessional, unsentimental, delicate, crystalline; his intensely autobiographical poetry, attuned to small epiphanies, coheres around memories of his childhood and adolescence in the South and employs the syntax of affective association with repeated injunctions to *Say* ("Middle Ear"), *Consider* ("Sign"), and *Suppose* ("13 Suppositions about the Ubiquitous"). With the quiet, spare elegance of contemporary free verse—the language of Robert Hayden and Michael Harper—he conveys his own melancholy, a gay man alone in the wake of loss (the specter of AIDS unspoken but present in poems like "Without John"), and describes his black kin with powerful precision.

"Down by the riverside" illuminates one intersection of personal and public history as Hamer guides us through a child's evolving consciousness of war as his father fights in Vietnam. "Choir Practice" explores Hamer's conscious reconnection, after long silence and alienation, to his family, heritage, and history from a multiplicity of angles, including his encounters with his hectoring muse, a slave woman calling him to authenticity. "Why / have you come here if not to sing?" she asks. His first volume, *Call and Response* (1995), charting ". . . the story / about how ways change over time according / to an urgency the young feel to insist themselves / in history. . . ." ("The Fit of Old Customs"), won the Beatrice Hawley Award. Structured as a baptism, the volume's poems are trellised along the secular ramifi-cations of black religious tradition, as the cadences of church music, the Bible, and sermons infuse the poems. The church organist, a "man who kept company with men," brings the assembled to confirmation, to deeper knowing: "Our family is here with us, even the dead and the not-born; / We are journeying to the source of all wonder, / We journey by dance. Amen" ("Goldsboro narrative #24: Second benediction").

Freer, less formally tied to meaning and traditional syntax, Hamer's second volume, *Middle Ear* (2000) makes of its title multiple metaphors, among them the ear as the organ of sentience ("a man goes deaf because he isn't listening") and the meaning of middle age ("I could be wrong, but I think my life is half over"). But it is only with age that wisdom comes: "change happens with small sights / Which accrete and feather. We see, we become" ("Arrival"). "The Tuning" claims the body as an instrument of precision, of music, as the poem itself, each filled with deep presence, astonishing vulnerability, anguished beauty: "Or say the instrument was a body, a dark one, / his own." "Crossroads," a poem borrowing early blues rhythms and based on the legend of blues musician Robert Johnson's bargain with the devil, is a lyric meditation on a young man's coming to terms with his selfhood, his wholeness, his homosexuality: "A man give his hand and he pulled me to the shore / Man give his hand, pulled me over to the shore / Told me if I come I wouldn't drown no more."

Forrest Hamer was born in 1956 in Goldsboro, North Carolina. This photograph was taken in July 2000 in Oakland, California, where Hamer has a psychotherapy practice.

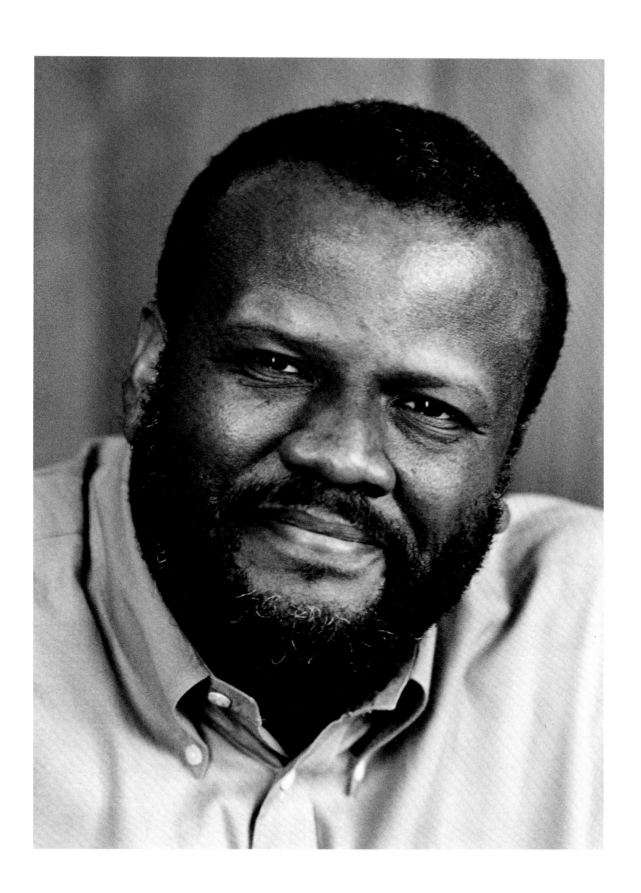

Michael S. Harper

In Michael S. Harper's poetry, traditional meter is often run off the page by the rhythms of jazz, driving words into each other like the collision of notes run together. Rhythm infuses his language with urgency, passion, and occasional mania. In the title poem to the 1974 volume *Nightmare Begins Responsibility*, Harper honors a jazz- and blues-inflected tradition to explore a personal landscape shaped by the loss of two sons: "up into essential calm unseen corridor / going boxscarred home, *mamaborn, sweetsonchild, / gonedowntown* into *researchtestingwarehousebateryacid / mama-son-done-gone.* . . ." Like good jazz, the mood in his poems can shift without a departure from the theme. The "pane-breaking heartmadness" described in this first poem is echoed more gently in "Reuben, Reuben," another eulogy for an infant son, "a brown berry gone / to rot just two days on the branch," as well as in "We Assume: On the Death of Our son, Reuben Masai Harper," a solo muted trumpet unreeling a long, sad tune: "A woman who'd lost her first son / consoled us with an angel gone ahead . . . / a fine brown powdered sugar, / a disposable cremation: / We assume / you did not know we loved you."

Thelonius Monk, Miles Davis, bebop pianist Bud Powell, saxophonist Lester Young, and especially the legendary John Coltrane are important influences in Harper's work. His first volume of poetry, *Dear John, Dear Coltrane* (1970), and the extraordinary "A Narrative of the Life and Times of John Coltrane: Played by Himself" ("I don't remember train whistles, or corroding trestles of ice / . . . but the feel of the reed on my tongue / haunts me even now . . .") reflect the extent to which great sorrow and redemptive joy become adjacent ends of a circling trajectory in Harper's poetry as well as in jazz.

Harper's poetic cosmology concerns myth and history: personal, racial, familial, ancestral—the link between the poet, the past, and the future that will be determined by how we choose to live in the present moment. He names the real freedom fighters of American history—Harriet Tubman, Josiah Hensen, Frederick Douglass—"black Heroes all" and names himself a part of that struggle, collapsing time frames and geography to include himself among those who "wrote our names on the hide-out walls / hung by the heavens in blood." And he insists, "being a Black poet and an American poet are two aspects of the same story, two ways of telling the same story. I'm both / and, not either / or."

Born in Brooklyn, New York, in 1938, Harper currently lives and teaches in Providence, Rhode Island, where he is Kapstein Professor at Brown University. The first poet laureate of the state of Rhode Island, Harper was awarded both a Guggenheim and an NEA, and he was twice nominated for the National Book Award. He has published nine volumes of poetry including *History Is Your Own Heartbeat* (1971); *Photographs: Negatives: History as Apple Tree* (1972); *Debridement* (1973); *Images of Kin: New and Selected Poems* (1977); *Healing Song for the Inner Ear* (1985); *The Beauty Shell* (1992); *Honorable Amendments: Poems* (1995); and *Songlines in Michaeltree: New and Collected Poems* (2000). Harper has also edited several anthologies of African American poetry.

This photograph was taken in March 2000 at Barnes and Noble bookstore in New York City.

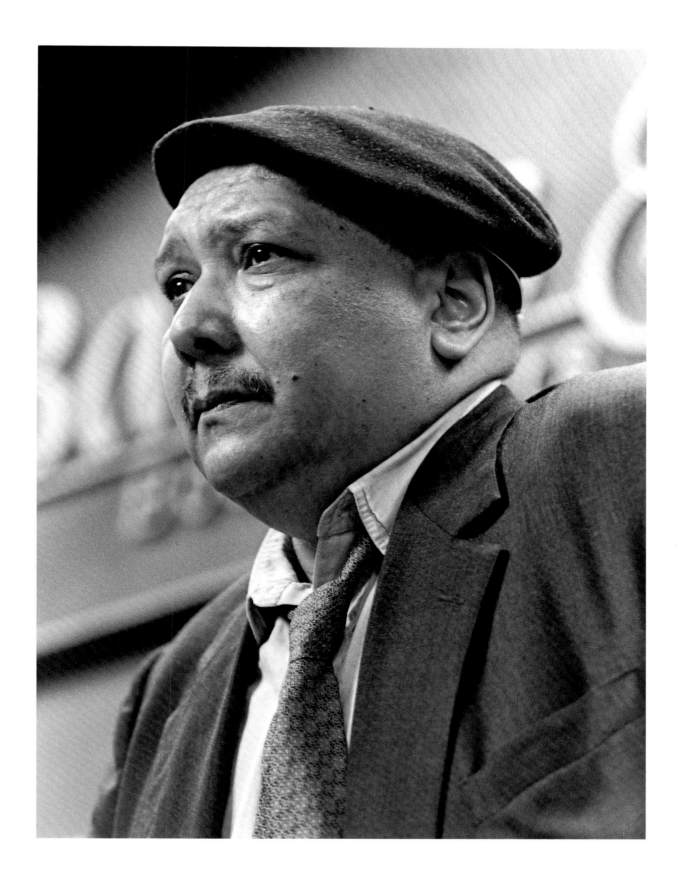

Essex Hemphill

In "American Wedding," a poem featured in the 1989 Marlon Riggs documentary, *Tongues Untied*, Essex Hemphill defiantly announces, "In america / I place my ring / on your cock / where it belongs." This film, like Isaac Julien's *Looking for Langston,* helped fuel Hemphill's growing national reputation as a singularly important poet. A model and forefather of the self-affirming, openly gay artist, he tells his mother in "In the Life," "Do not feel shame for how I live / I chose this tribe / of warriors and outlaws."

Disavowing the placating comfort of such things as the NAMES quilt ("It's too soon / to make monuments / for all we are losing, / for the lack of truth / as to why we are dying . . .") Hemphill became *the* in-your-face gay black poet, performer, and activist of his era. In a time of a rapidly metastasizing AIDS crisis, Hemphill advocated unsafe art: "Safe for me equals ineffective—men who will not take risks in their intellect and who will not take risks in their compassion."

Hemphill's poetic line is sharp, short, and usually shorn of figurative language. Rejecting the Black Arts subtext of homophobia, he adopted the movement's technique of punching through false consciousness with declarative sentences. In "The Occupied Territories" he writes, "your penis your vagina, . . . / these belong to the State. / You are not to touch yourself / or be familiar with ecstacy. / The erogenous zones / are not demilitarized."

Hemphill wrote unsparingly about life as a gay man ("Better Days"). He uses his alienation from straight black masculinity to proffer critiques of black homophobia ("Commitments"), sexual hypocrisy ("Isn't It Funny"), and street misogyny. In "To Some Supposed Brothers," he uses a conditional identification, "we so called men / we so called brothers," to "wonder why it's so hard / to love *our* women / when we're about loving them / the way america love us." Hemphill reserves his most severe censure for an "america" that is rarely capitalized in his poems. He speaks to an American oppression shared by blacks of both genders and all sexual orientations.

"Heavy Breathing" is Hemphill's finest poem. Borrowing from the rhetoric of the AIDS community ("silence = death"), the poem indicts the "scandal-infested leadership" of that community as well as the hypocrisy of all those communities—Black Church and family, Civil Rights movements, predominantly white queer communities—that have excluded him. As A. Boxwell articulately argues, the poem "engages in elaborate metaphorical play between individual and political bodies . . . powerfully draw[ing] out the metaphoric connections between the HIV-afflicted gay man and a sickened and untreated America racked by violent convulsions."

Hemphill was born in Chicago in 1957. Winner of a National Endowment for the Arts poetry fellowship, he published two chapbooks, *Earth Life* (1985) and *Conditions* (1986), and a larger collection of prose and poetry, *Ceremonies* (1992). A contributor to Joseph Beam's historic black gay anthology, *In the Life* (1986), he subsequently edited *Brother to Brother: New Writing by Black Gay Men* (1991). Essex Hemphill died November 1995 of complications relating to AIDS. Nonetheless, as he wrote in "Serious Moonlight": "I'm still here hanging on / refusing to be intimidated." This photograph was taken at the San Francisco OutWrite Conference in 1990.

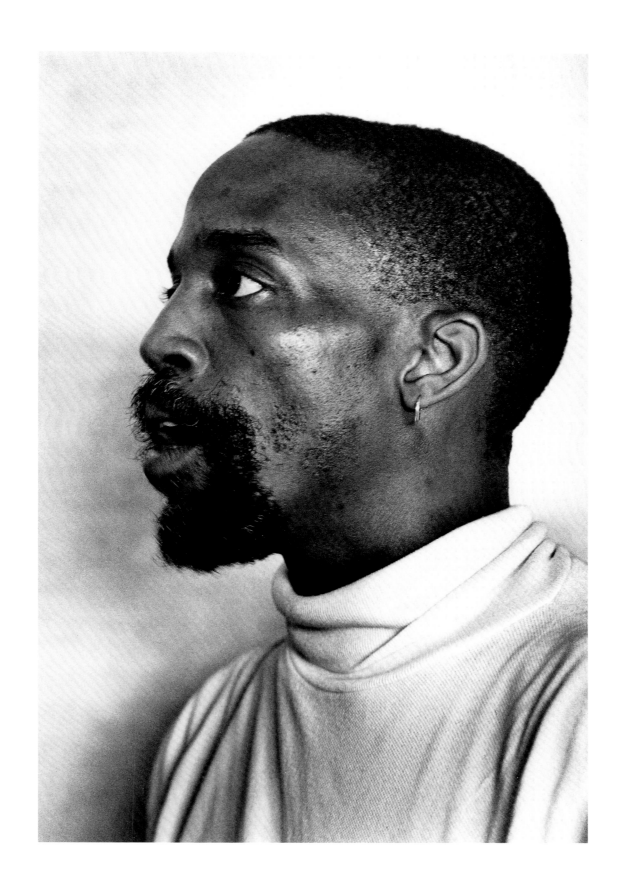

Charles R. Johnson

If novelist Charles R. Johnson was known only for early successes in the fields of journalism, political cartooning (*Black Humor*, 1970), and screenwriting (*Charlie's Pad*, 1971), his achievement would have been impressive enough. But in 1974, at the age of twenty-six, Johnson published *Faith and the Good Thing*—the first of a string of novels and short stories that added a deeply philosophical dimension to the craft of fiction rare in American letters.

"As a writer," he said in an interview printed in *Contemporary Authors* (1999), "I am committed to the development of what one might call a genuinely systematic philosophical black American literature, a body of work that explores classical problems and metaphysical questions against the background of black American life. Specifically, my philosophical style is phenomenology, the discipline of Edmund Husserl, but I also have a deep personal interest in the entire continuum of Asian philosophy from the Vedas to Zen, and this perspective inevitably colors my fiction to some degree."

Despite the reach of such intellectual grappling, Johnson grounds his writing in an irrepressible humor and a straightforward, accessible prose that wears its erudition lightly. Eschewing the realism of so many traditional black narratives that portray their protagonists as victims of a world that is not theirs to fashion, Johnson delights in anachronisms, neologisms, and surrealistic touches that subvert the reader's expectations. In *The Oxherding Tale* (1982), Johnson not only models his reworked slave narrative on a series of fifteenth-century drawings illustrating a Zen parable of enlightenment, he introduces Karl Marx as a character to the antebellum South.

Like a Johnson protagonist, the reader learns to give up a constricting "individuality" by paying close attention to the lessons that others offer throughout the text. Even Johnson's slave captain from the National Book Award–winning *Middle Passage* (1990), a witty riff on Melville's Captain Ahab by the name of Ebenezer Falcon, proffers a philosophical and provocative take on the institution constructed out of black dehumanization: "Conflict . . . *is* what it means to be conscious. Dualism is a bloody structure of the mind. Subject and object, perceiver and perceived, self and other—these ancient twins are built into mind like the stem-piece of a merchant-man. We cannot *think* without them, sir. And what, pray, kin such a thing mean? Only this, Mr. Calhoun: They are signs of a transcendental Fault, a deep crack in consciousness itself. Mind was *made* for murder. Slavery, if you think this through, forcing yourself not to flinch, is the social correlate of a deeper, ontic wound."

Charles Johnson was born in 1948 in Evanston, Illinois. He has also published *The Sorcerer's Apprentice* (1986), a collection of short fiction; *Being & Race* (1988), an examination of black writing from the seventies and eighties; and *Dreamer* (1998), his latest novel drawn from the life of Dr. Martin Luther King, Jr. He currently teaches at the University of Washington in Seattle. This photograph was taken in March 2000 at the Seattle Repertory Theater in a public dialogue with playwright August Wilson.

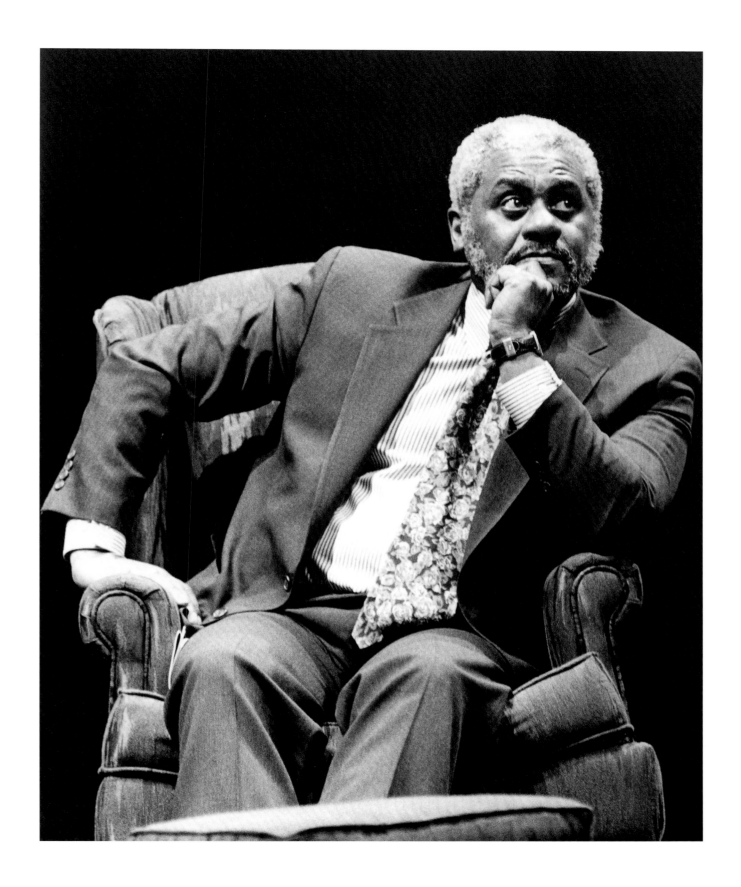

June Jordan

June Jordan has written poems that demand our deepest apprehension, that take us in as breathing, that insist that we cannot, must not, strip things of their complexity. Her work is a cartography of resistance against racism, against political, cultural, and economic colonialism and misogyny. She insists on the necessity of taking action against injustice, instead of passively—or hopelessly—waiting for things to change, because, as Jordan has so wryly observed, no one will do it for us— "God is vague and he don't take no sides."

A writer who has concerned herself with the most contemporary of issues, she has also reached all the way back to the beginnings of African American poetry; in "Something like a Sonnet for Phillis Miracle Wheatley," Jordan reclaims Phillis Wheatley, once despised as a colluder in her own enslavement, for the poet of courage and genius that she was. Her poems take place in Chile, Managua, Soweto, Lebanon, as well as the streets of America. In "I Celebrate the Sons of Malcolm," she claims as family, as brothers-in-arms the "powerful, implicit, passionate, and somber" sons of Malcolm X. Her poems are a singular howl against the relentless laughter of evil. When she is angry, that anger is purposeful. Her voice is decisive, empowered. It is also one long, incredibly sweet saxophone of love for those she has reason to claim in community and sisterhood. In an essay written more than twenty years ago, June Jordan defines her life commitment to ending "those tyrannies, those corrosions of sacred possibility [of human love.]" In the title poem of *Things That I Do in the Dark*, Jordan explains her poems' urgency: "These poems / they are things that I do / in the dark / reaching for you / whoever you are / and / are you ready?"

A prolific writer and poetic genius, born in Harlem in 1936 and raised in the Bedford-Stuyvesant section of Brooklyn, Jordan is most recently the author of *Soldier: A Poet's Childhood* (2000), a bittersweet, unsettling memoir of her childhood as the daughter of West Indian immigrant parents. In addition to many volumes of poetry, including *Who Look at Me* (1969), *Passion* (1980), *Living Room: New Poems 1980–1984* (1985), *Naming Our Destiny: New and Selected Poems* (1989), *Haruko/ Love Poems* (1994) and *Kissing God Goodbye* (1997). She is the author of a biography, *Fannie Lou Hamer* (1972); several plays, one of which, *The Issue*, was directed by Ntozake Shange at the New York Shakespeare Festival; the young adult novel *His Own Where* (1971); and five collections of political essays: *Civil Wars* (1981), *On Call* (1985), *Moving Towards Home* (1989), *Technical Difficulties* (1992), and *Affirmative Acts* (1998). Jordan is also the author of two librettos, *Bang Bang Uber Alles* (1985) and *I Was Looking at the Ceiling and Then I Saw the Sky* (1995), and *Poetry for the People: A Blueprint for the Revolution* (1995), a guide to writing, teaching, and publishing poetry.

Educated at Barnard College and the University of Chicago, winner of numerous prizes and honors, among them, the Prix de Rome in environmental design, Jordan is currently a professor of African American studies at the University of California, Berkeley. The photograph of Jordan was taken at the university in 1986.

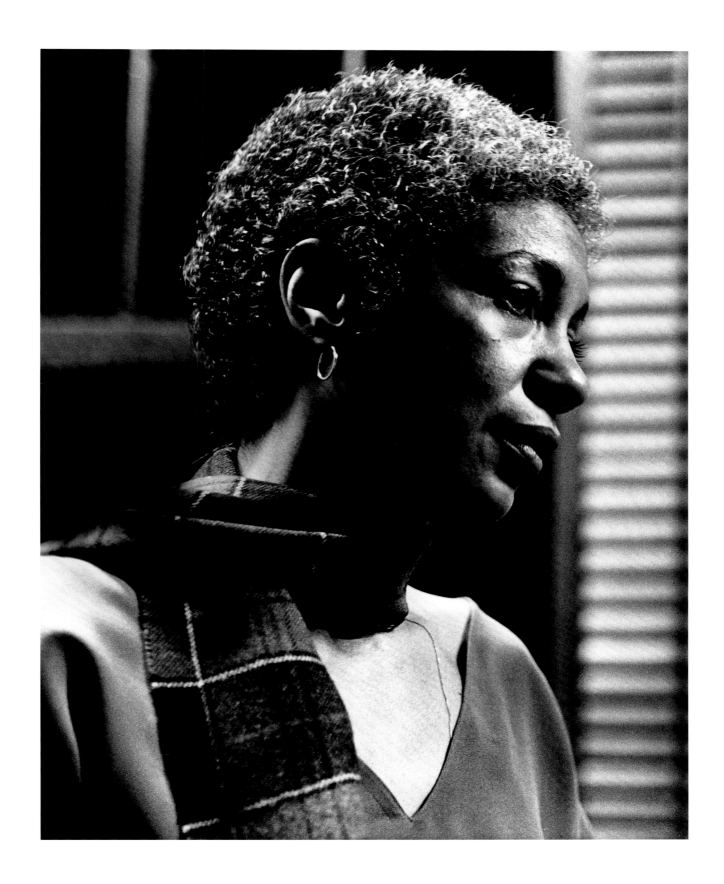

Randall Kenan

Dubbed "our 'black' García Márquez" by Terry McMillan and a writer who represents "the hope and future of Western literature" by Dorothy Allison, Randall Kenan announced his arrival on the literary scene in 1989 with the much-praised debut novel *A Visitation of Spirits*, which deals with homosexuality in the rural South.

Through a casual mixing of supernatural and surreal elements in an otherwise realistic framework, the novel shifts between two narratives in different time periods, switches from third- to first-person, and includes disquisitions on such subjects as hog killing and the preparation of tobacco. Attracted to his boyhood friend John Anthony, "a copper-skinned, spindly boy [who] had loved books, too," the studious, ambitious, and doomed fifteen-year-old Horace Cross embarks on a series of homosexual relationships that fill him with joy and terror. Confronted with familial and community disapproval, he retreats to an exile of guilt and confusion, imagining baptism as salvation: "There was a gurgling and a surging in Horace's ears and his heart thumped with panic. Did the bubbles that escaped from his trembling mouth contain that evil, former self?" In his journey into the vortex of memory, desire, and repression, he turns to fantasy, hallucination, and the occult, "an unseen world full of archangels and prophets and folk rising from the dead, a world preached to him from the cradle on, and a world he was powerless not to believe in as firmly as he believed in gravity and the times table."

Kenan explores the odd, intermingled lives of the residents of the novel's setting—Tims Creek, North Carolina—from an even greater variety of perspectives in *Let the Dead Bury Their Dead* (1992), a book of short fiction in which spirits and spirituality mix with suspicion and superstition. We see reality like a television receiving two channels at once, the primary channel clear, the second one merely ghosts and shadows. In "Clarence and the Dead," three-year-old Clarence Pickett begins talking with his neighbor's ancestors and communing with a talking hog. The title story, a summation of Kenan's signature mixture of genres and styles—dialogue in dead-accurate black English, nineteenth-century diary entries, florid epistles—reveals the origins of the ancestral Cross surname.

Inspired by the nonfictional odysseys of John A. Williams and Albert Murray, Kenan wrote the monumental *Walking on Water: Black American Lives at the Turn of the Twenty-First Century* (1999), the fruit of a six-year, seventy-five-thousand mile road trip. He interviewed nearly two hundred people (including a retired railroad worker, a twelve-year-old schoolgirl, a church janitor, a judge, an AIDS activist, an ex-gang member, and writers Haki Madhabuti, Dorothy West, and Octavia Butler) to try to answer the question, "What does it mean to be black?" Kenan's novelistic skills in this travelogue bring alive this vast panorama of African Americans from Martha's Vineyard to Anchorage, Alaska.

Born in Brooklyn in 1963 and reared in Chinquapin, North Carolina, Kenan is the winner of both a Guggenheim and a Prix de Rome, and the author of the young-adult biography *James Baldwin* (1994). He currently teaches at the University of Memphis. This photograph was taken at a National Queer Arts Festival reading in San Francisco in June 2001.

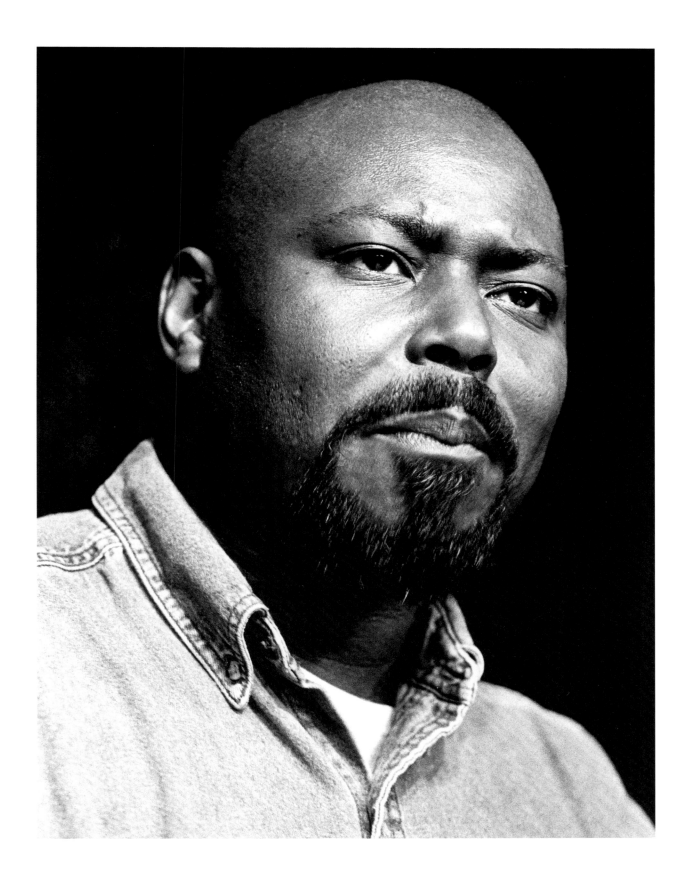

Jamaica Kincaid

Fierce, pitiless, mesmerizing, simultaneously spare and sensuous, unanchored by any conventional sense of morality, Jamaica Kincaid's fiction is moored by loss, absence, suffering, willfulness, a profound, unapologetic self-absorption, and a relentless struggle against dominion—familial or political. The young Antiguan daughter's struggle for autonomy and separation from a despised and adored mother permeates Kincaid's early fiction and reappears, in an even more powerful guise, in the astonishing, icy genius of *Autobiography of My Mother*. This 1996 novel details the beautiful, terrifying particulars of an embittered, abandoned, merciless child's consciousness. Covering seventy years in the life of Dominican subject Xuela Claudette Richardson, the novel begins its soliloquy with the wrenching observation that haunts this narrative: "My mother died at the moment I was born, and so for my whole life there was nothing standing between myself and eternity; at my back was always a bleak, black wind." As Tai Moses so evocatively observes, "With the bitterness of the orphan and the rage of the dispossessed, Xuela is Kincaid's flesh-and-bone symbol for the incalculable, tragic effects of colonial rule upon Dominican culture. . . . Xuela *is* Dominica—an orphaned country in shambles, its people enslaved and conquered, its past a graveyard. . . . [Xuela] flaunts the scars of her past like gaudy jewelry. . . . We are left reeling in a dazzling storm of language."

Kincaid's first book, the short story collection *At the Bottom of the River* (1983), contains the remarkable vignette, "Girl," a two-page continuous sentence consisting solely of a controlling West Indian mother's admonitions. Like the narrator of Kincaid's subsequent novel *Lucy* (1990)—a nineteen-year-old, estranged from her mother and living as an au pair, who bitterly inquires, "After all aren't family the people who become the millstone around your life's neck?"—the narrator of *Annie John* (1985) perversely wishes to violate every social taboo. Kincaid constructs throughout her work a powerful trope of resistance, an aggrieved character who will not submit, symbolized by a retaliating monkey. (In *A Small Place*, the racist headmistress orders her young charges to "stop behaving as if they were monkeys just out of trees.") In all of Kincaid's novels, a mother—that reflection of colonial power—throws stones at monkeys, an act that subsequently incurs the Signifying Monkey's revenge. "One day," Lucy recalls, "when [my mother] threw the stone, the monkey caught it and threw it back. When the stone struck my mother, the blood poured out of her as if she were not a human being but a goblet with no bottom to it."

Jamaica Kincaid was born Elaine Potter Richardson in St. John's, Antigua, in 1949. Her nonfiction includes *A Small Place* (1988), *My Brother* (1997), *My Garden (Book)* (1999), and *Talk Stories* (2001), a collection of Kincaid's brief *New Yorker* "Talk of the Town" ruminations. Jamaica Kincaid lives in Bennington, Vermont, and teaches at Harvard University. This photograph was taken at A Clean Well Lighted Place for Books in Marin County in 1996.

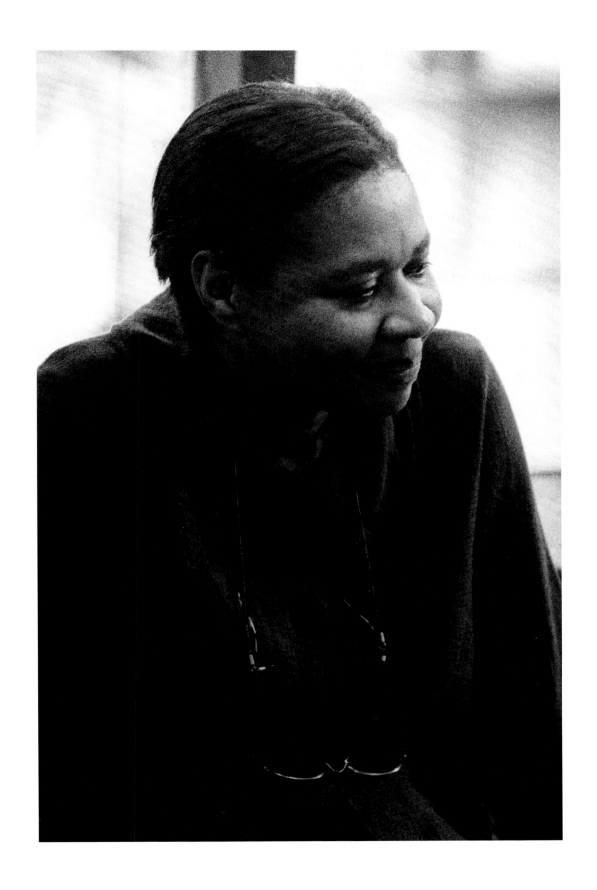

Yusef Komunyakaa

Yusef Komunyakaa marries a profound moral authority to a shimmering emotional intelligence and an unerring sense of image, line, syntax, speech, and aesthetics in poems full of surprises and engagement, celebrations and confrontations. In his prose collection, *Blue Notes: Essays, Interviews, and Commentaries* (2000), he describes poetry as "a kind of distilled insinuation," adding that "poetry is an act of meditation and improvisation, and *need* is the motor that propels the words down the silent white space."

Both blues and jazz figure strongly in his poetry. *Neon Vernacular: New and Selected Poems* (1993), containing work from seven previous collections, was awarded the Pulitzer Prize. The complex, dual-columned poem "Changes; or Reveries at a Window," included in this collection, offers the charged mantra of Komunyakaa's poetics ("Don't try to make any sense / out of this; just let it take you / . . . & keep you human") and connects it to the music aesthetics of John Coltrane, who was willing to surrender to the music, "each riff & word / a part of the whole . . . / a matrix of blood and language / improvised on a bebop heart." An earlier volume, *Copacetic* (1984), the title a jazz term originated by Bill "Bojangles" Robinson, contains blues poems for Leadbelly, Thelonius Monk, and Charles Mingus, and the love poem, "Woman, I Got the Blues."

Komunyakaa served in Vietnam and was awarded a Bronze Star for his work as war correspondent for the *Southern Cross*. Fourteen years later, poems that engaged this experience began tumbling out, collected in *Toys in a Field* (1986) and *Dien Cai Dau* (1988). In "Starlight Scope Myopia," compassion, the recognition of the enemy as not just human, but beautiful, ignites the vision of the soldier who is "Peer[ing]down the sights" of his M-16 at Vietnamese soldiers, "Caught in the infrared": "One of them is laughing. / You want to place a finger / to his lips & say 'shhhh.' / . . . This one, old, bowlegged, / you feel you could reach out & take him into your arms." *Dien Cai Dau* (Vietnamese for "crazy") contains "Tu Do Street," "We Never Know," "Thanks," and Komunyakaa's searing masterpiece, "Facing It" ("My black face fades, / hiding inside the black granite. / . . . I go down the 58,022 names, / half-expecting to find / my own in letters like smoke.")

Yusef Komunyakaa was born in 1947 in Bogalusa, Louisiana, and his poetry frequently depicts images from his childhood there. "Venus's-flytraps" (*Magic City*, 1992) reveals a five-year-old boy flooded with imagination and wisdom: " . . . I don't supposed to be / This close to the tracks. / . . . Sometimes I stand so close / I can see the eyes / Of men hiding in boxcars / . . . I wish I knew why / The music in my head / Makes me scared. / But I know things / I don't supposed to know. . . ." This boy reappears in the collection, now nearly grown, in "Slam Dunk and Hook" and "My Father's Love Letters."

Komunyakaa currently teaches at Princeton University. His most recent collections include *Thieves of Paradise* (1998), *Talking Dirty to the Gods* (2000), and *Pleasure Dome: New and Collected Poems* (2001). This photograph was taken in Berkeley in March 2000.

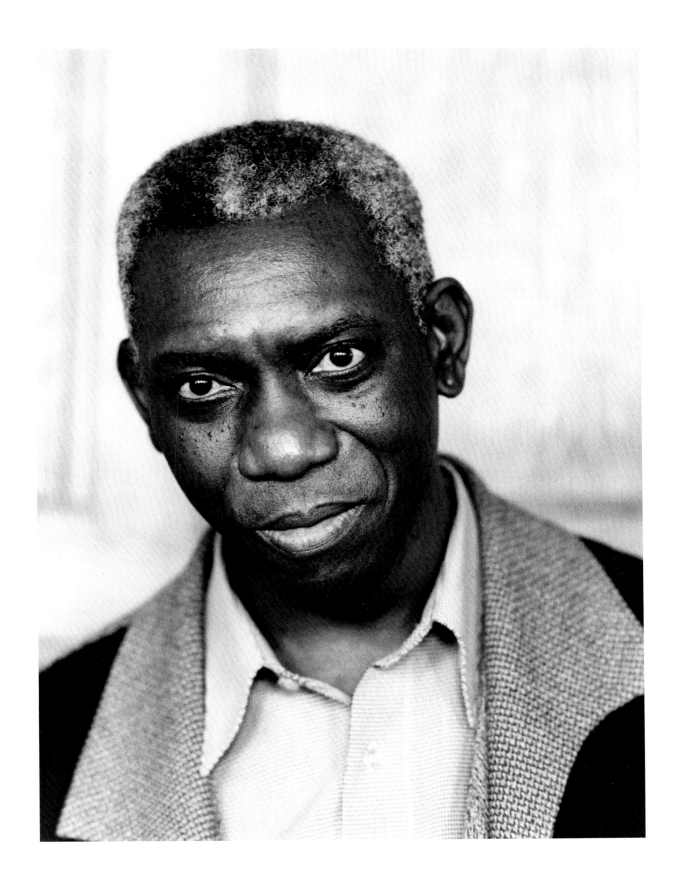

Audre Lorde

The feminist vision which informs Audre Lorde's poetry is more than subversive; it is incendiary. In poetry and prose that is as compelling for its ethical vision as for its language, Lorde dares to imagine a changed world, insisting, "For women . . . poetry is not a luxury. It is a vital necessity of our existence. It forms the quality of light within which we predicate our hopes and dreams towards survival and change, first made into language, then into idea, then into more tangible action." Reversing the racist stereotypes connoting darkness with fear, hatred, and death, her poems associate darkness with strength, integrity, beauty, vision, and magic.

The title poem from *Coal* (1976) invokes a powerful and joyous recognition of self, and of the beauty of blackness: "I am Black because I come from the earth's inside / now take my word for jewel in the open light." The love poems from *The Black Unicorn* (1978) are sensuous, tender, fiercely passionate, tasting of honey and limes and earth. Dreaming in "Woman" of a time when "the commonest rock / is moonstone and ebony opal," Lorde envisions racial healing between white and black women. In "Meet," she borrows from the legend of Mawulisa as a prophecy, vowing to resist the lies uttered against loving, and the censure and denial of lesbian relationships. In "Power," she warns that real power is not the simple possession of the means of violence, but a means to individual transformation, insisting that the appropriate use of *this* power will engender the muscular, cohesive vision that makes social revolution possible. Poems such as "Power," "Need: A Choral of Black Women's Voices," and "Afterimages" (a brilliant choral echo of Gwendolyn Brooks's poem about the murder of Emmett Till), as visceral and devastating as the actual events they describe, avoid any semblance of conventional poetic diction or syntax. In their unflinching gaze into much that is nightmare in American culture, many of these are not comforting poems. But because Lorde's work imagines what poet Adrienne Rich has called, "the possibilities of truth between us," they are poems which chart a new, essential geography, one whose terrain we ignore only at our own peril.

Self-described "Black lesbian, mother, warrior, poet," Audre Lorde was born in 1934 in New York to West Indian parents. Her struggle with cancer, depicted in both *The Cancer Journals* (1980) and *Burst of Light* (1988), she regarded as "only another face of that continuing battle for self-determination and survival that black women fight daily, often in triumph." Scholar, publisher, author of the biomythography, *Zami: A New Spelling of My Name* (1982), as well as numerous volumes of poetry, including *The First Cities* (1968); *Cables to Rage* (1970); *From a Land Where Other People Live* (1973); *The New York Head Shop and Museum* (1974); *Between Our Selves* (1976); *Our Dead Behind Us* (1986); *Undersong: Chosen Poems Old and New* (1992); *The Marvelous Arithmetics of Distance* (1993); and a posthumous volume, *The Collected Poems of Audre Lorde,* (1997). Audre Lorde died of breast cancer in 1992. This photograph was taken at the Women Against Violence and Pornography in Media Conference in San Francisco in 1978.

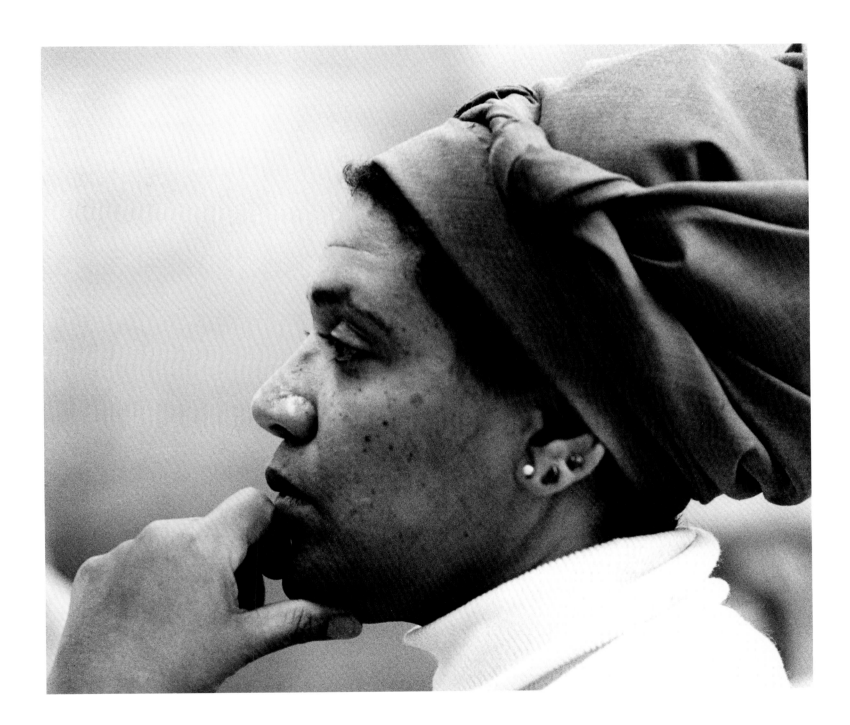

Nathaniel Mackey

Student of syntax, master of language, Nathaniel Mackey works as a poet, novelist, editor, and educator to explore music and mysticism across the cultures of Africa, the Caribbean, North and Latin America. With his parallel serial series of poetry and epistolary prose, he extends the traditional boundaries of genre.

The multivolume serial novel *From a Broken Bottle Traces of Perfume Still Emanate* began as a few "Angel of Dust" letters in the poetry books *Septet for the End of Time* (1983) and *Eroding Witness* (1985). The first collected volume of letters to the Angel of Dust from musician/composer "N." was *Bedouin Hornbook* in 1986, followed in 1993 by the second volume *Djbot Baghostus's Run*. Mackey recently published a third volume *Atet, A.D.* Reflecting on Robert Duncan quoting Louis Zukovsky, who observed that we write one poem all our lives, Mackey admitted that he didn't know how many volumes his completed novel will fill, although he did recently publish an excerpt from the forthcoming fourth volume. Mackey's serial poem "Song of the Andoumboulou" is anchored—at times loosely—in the Dogon culture of Mali. The poem moves like a long jazz improvisation, in which cultural commentary becomes one of many melodies recursively reflected through solos on different instruments. In this way, Mackey is the musician/composer sculpting language like sound, striving for the echo after the note that sounds more true than the note itself, pushing language into music.

In the introduction to *Moment's Notice: Jazz in Poetry and Prose* (1993), Mackey and his coeditor Art Lange comment on the vibrant interplay between jazz and the written word: "It is particularly unsurprising that a music which so frequently and characteristically aspires to the condition of speech, reflecting critically, it seems, upon the limits of the sayable, should have provoked and proved of enormous interest to practitioners of the word." By collecting and publishing a wide range of music-influenced writing—both in this anthology and in the many volumes of the literary magazine *Hambone*—Mackey defines his discipline, insisting that this writing be read as a conversation among artists. He equips readers with many of the critical tools they will need to appreciate this writing: a wide knowledge of jazz history, an appreciation for the mutability of genre boundaries, and a vigilant eye, always looking for the line to connect the piece with the work that has come before. Al Young's approach to the musical memoir has clearly influenced Mackey's novel. The linguistic blues play of Harryette Mullen's *Muse and Drudge* provides a choral echo to many stanzas in Mackey's *Whatsaid Serif*. As in Clarence Major's *Dirty Bird Blues*, the music in Mackey's work is so alive that it calls the reader across lines of genre, filling with genius and invention the chasms assumed to separate categories of writing.

Nathaniel Mackey is a professor at the University of California, Santa Cruz. This photo was taken at the San Francisco Book festival in 1999.

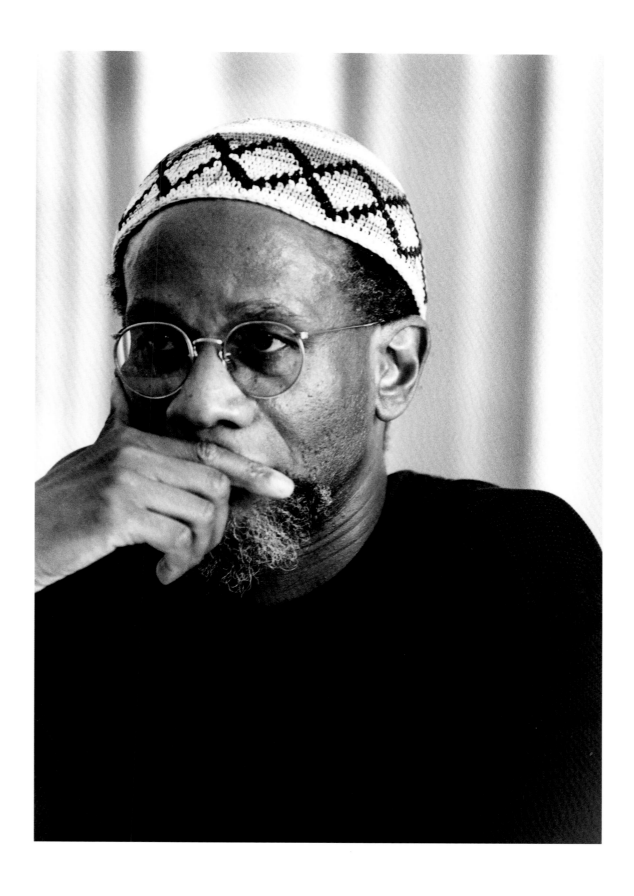

Haki R. Madhubuti

Poet Haki R. Madhubuti, who recently described black poetry as "the best medicine to strengthen a weak cultural immune system," was, with Larry Neal and Amiri Baraka, one of the founders of the Black Arts Movement. Affectionately described by Gwendolyn Brooks as "an interpreter and protector of Blackness . . . a subscriber to what is beautiful in the world . . . [possessing] the kind of toughness that doesn't just 'sass its mammy' but goes right through to the bone," Madhubuti used his own success as a poet to create venues for other serious black writers because, as he observed in a poem from *Think Black!* (1967): "most / poets who poet / seldom / die from over exposure." Madhubuti founded Third World Press and the Institute of Positive Education; with Neal, he also created The Black Books Bulletin.

Madhubuti's poetry serves as a topological map of the essential journey of black community- and nation-building. In "Blackman/an Unfinished History," he charts some of the journey. With a jazzy "Zoom Zoom" and "click click" the poem announces: "Watch out world greatness is coming." In another poem, he tempers this voice of celebration and solidarity with a call to active revolution: "i ain't seen no poems stop a .38, / . . . i ain't seen no metaphors stop a tank, . . . / & until my similes can protect me from a nightstick / i guess i'll keep my razor / & buy me some more bullets." The title poem from *Don't Cry, Scream* (1969) is dedicated to John Coltrane, and like Coltrane's jazz improvisations, it "rid[es] the rails / of novation. / blowing / melodics," following the poem's own right hand column instructions to "improvise / with / feeling."

Madhubuti's early work was characterized by the use of vernacular syntax and new words created out of sequences that might otherwise simply be hyphenated ("auntjimamablack" and "blackisbeautifulblack,"), as well as a strong sense of both rhythm and sound, and unconventional use of line breaks, diagonals, and spatial arrangements. "The B Network" is playful and jazzy but entirely serious in its cultural advice: "brothers need to bop to being Black & bright & / above board." In a 1970 essay discussing cultural nihilism and self-destructiveness, he points out that "It's not enough to say *I'm Somebody*: we've always known that. The question *is* who/what?"

Madhubuti is the author of twenty-two books. His poems and essay collections extol, among other values, meditation, prayer, contemplation, silence, exercise, vegetarianism, knowledge, work, play, reciprocity in relationships, and respect for black women. His books include *From Plan to Planet—Life Studies: The Need for Afrikan Minds and Institutions* (1973), *Black Men, Obsolete, Single, Dangerous? Afrikan American Families in Transition: Essays in Discovery, Solution and Hope* (1990), and *Claiming Earth: Race, Rage, Rape, Redemption: Blacks Seeking a Culture of Enlightened Empowerment* (1994), a volume that defines victimhood as "the prerequisite to self-hatred and dependency, political and economic neutralization and joyless living." His most recent book is *Tough Notes: Letters to Young Black Men* (2001).

Madhubuti was born Don Luther Lee in 1942 in Little Rock, Arkansas; in 1973, he changed his name to Haki R. Madhubuti, which in Swahili means "Justice, Awakening, Strong." He is a professor of English and founder and director emeritus of the Gwendolyn Brooks Center at Chicago State University. This photograph was taken in Chicago in June 2000 in Madhubuti's office at the Third World Press

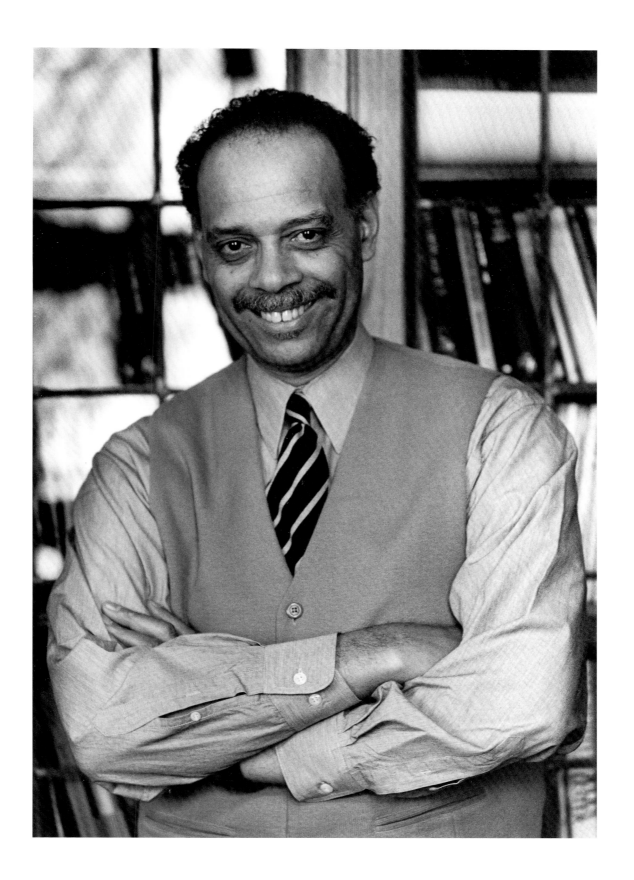

Clarence Major

Novelist, poet, photographer, essayist, and scholar, Clarence Major is also a celebrated visual artist whose paintings are the subject of Bernard Bell's monograph, *Clarence Major and His Art: Portraits of an African American Postmodernist* (2001), and a lexicographer who produced two definitive collections of African American slang.

Assertively challenging the traditional tenets of narrative, Major explores the fragmentary nature of identity, examining the possibility that identity is truly pixilated, a disjointed mass that, like photo-realist painter Chuck Close's methodological reconfigurations, appears whole only from a distance. Ntozake Shange describes Major's work as "breaking the linear tradition in black literature, moving us from narrative to the crux of the moment." The narrator of *Reflex and Bone Structure* (1975) insists, "I'll make up everything from now on. I'll do anything I like. I'm extending reality, not retelling it." Then in a single sentence, he manages to anachronistically blend fantasy, geography, history, dance, penology, the judicial system, and racial politics when he offhandedly observes that his buddy Canada "does a transatlantic lindy hop from Europe to the states and landing in a courtroom in the South . . . accidentally gets sentenced to the penitentiary as one of the Scottsboro boys."

My Amputations (1986) also disputes assumptions about the structure of a narrative text. Written in blocks, or panels, not paragraphs or chapters, it chronicles the story of an ex-con named Mason, a young black writer who "wanted so much to leave an imprint: to inform with form, to push a verbal text beyond a pretext." Major's blues-infused language saturates *Dirty Bird Blues* (1996). When the protagonist's future sister-in-law coldly comments, "Cleo said you're a musician. . . . Is that *all* you do?" Manfred invokes the blues as a protective amulet and imagines saying, "Naw I can boogie, I can fuck all night, I can throw a pot of pig knuckles out the window, run outside and catch the pot before it falls without spilling a drop, I can howl better than a wolf, I can raise the dead from the swampland with my blues [and] I can scoobedoo you an yo mama. . . ." Manfred also conceptualizes the blues as a potential agent of racial reconciliation: "He sat there watching the white folks . . . strutting or jumping to the same rhythm anybody else strutting or jumping to. They must got they blues when it comes to love . . . like us, they dream they hearts gon mend and be thinking love gon overcome everything else, like us."

Major's poems, too, are emotionally cogent but resist linearity and easy explication. *Configurations: Selected Poetry 1958–1998* (1998), which was nominated for the National Book Award, contains "The Slave Trade: View from the Middle Passage," a long narrative poem evoking Equiano, European colonialism, African complicity in the slave trade, the Bible, abolitionists, missionaries, fairy tales, racist iconography, folksongs, historical cartoons, and the hypocrisy of American slave-keeping presidents Washington and Jefferson.

The recipient of two Pushcart Prizes and a Fulbright, Clarence Major is a professor of English at the University of California, Davis. His most recent books are *Afterthoughts: Essays and Criticism* (1998), and *Necessary Distance: Essays and Criticism* (2001). Major was born in 1936 in Atlanta, Georgia. This photograph was taken in February 2000 in Major's Davis, California, home.

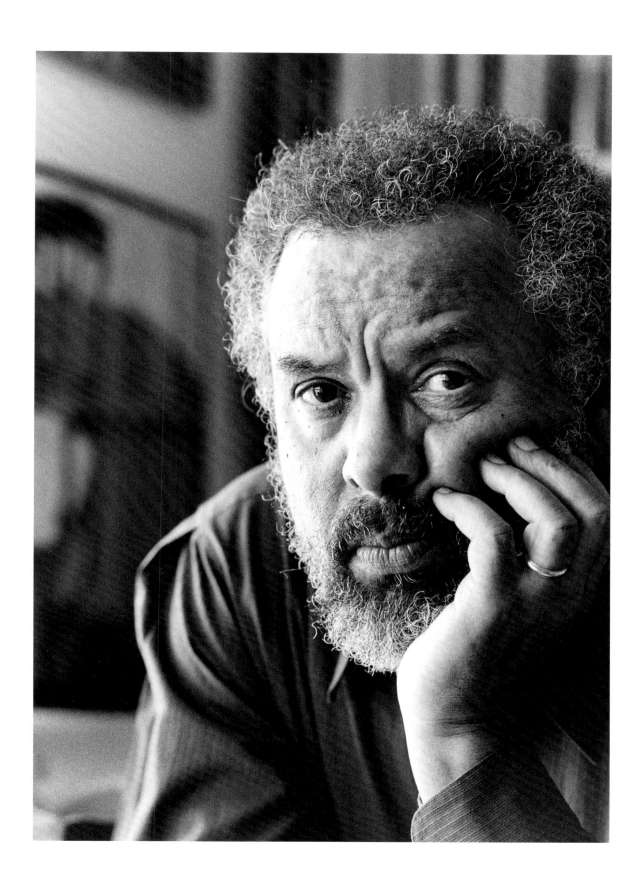

Paule Marshall

Beginning her career during the eclipse of Zora Neale Hurston's, Paule Marshall essentially reinvented black feminist writing, excavating out of her own experience the themes of feminist empowerment through language, storytelling, and a ritualized connection to the black diaspora. Her link to the diaspora was more than an intellectual idea: her parents were both Barbadian immigrants, and she grew up listening to the savory Bajun of the women she terms "the poets in the kitchen." " 'Soul-ly-gal, talk yuh talk!' they were always exhorting each other. 'In this man world you got to take yuh mouth and make a gun!'"

Marshall displayed her gift for poetic English in her stunning debut novel, *Brown Girl, Brownstones*, which portrays the complex coming-of-age of Selina Boyce, American born but equally a daughter of the Caribbean. Torn between her bright dreamer of a father and the flinty pragmatism of her mother, Selina struggles with Silla, who, in a rage, "stared at [her daughter] as she would at a stranger . . . a dull light stirred in her eyes like the last vestige of life. 'All along I did feel something was wrong . . . you never had no uses for me, but did think the sun rose and set 'pon yuh father alone.' . . . 'Mother,' [Selina] said gently, 'I have to disappoint you. Maybe it's as you once said: that in making your way you always hurt someone. I don't know. . . . ' Then remembering something Clive had said, she added with a thin smile, 'Everybody used to call me Deighton's Selina but they were wrong. Because you see I'm truly your child.'"

Ten years later, Marshall equaled her achievement with a novel set entirely in the Caribbean, one of the finest depictions of the postcolonial condition any writer has produced. The canvas of *The Chosen Place, the Timeless People* (1969) is broader, but Marshall's writing, by turns lyrical, analytical, alive in all ways to the nuances of her rich characters, renders the fictional island of Bourne heartbreakingly real. In 1983 Marshall published the third book of the trilogy that describes the infamous Triangle Trade, Africa–the Caribbean–North America, in reverse. *Praisesong for the Widow*, her greatest popular success, traces the spiritual itinerary of black American Avey Johnson from the soulless materialism of her husband's "success" to the full reclamation of her half-buried African heritage.

Paule Marshall was born in 1929 in Brooklyn, New York. She has won many awards for her work, including the MacArthur Fellowship in 1992. The Helen Gould Sheppard Chair of Literature and Culture at New York University, Marshall is also the author of *Soul Clap Hands and Sing*, a 1961 collection of short fiction, as well as two other novels: *Daughters* (1991) and *The Fisher King* (2000). This photograph was taken in Professor Barbara Christian's classroom at the University of California, Berkeley, circa 1980.

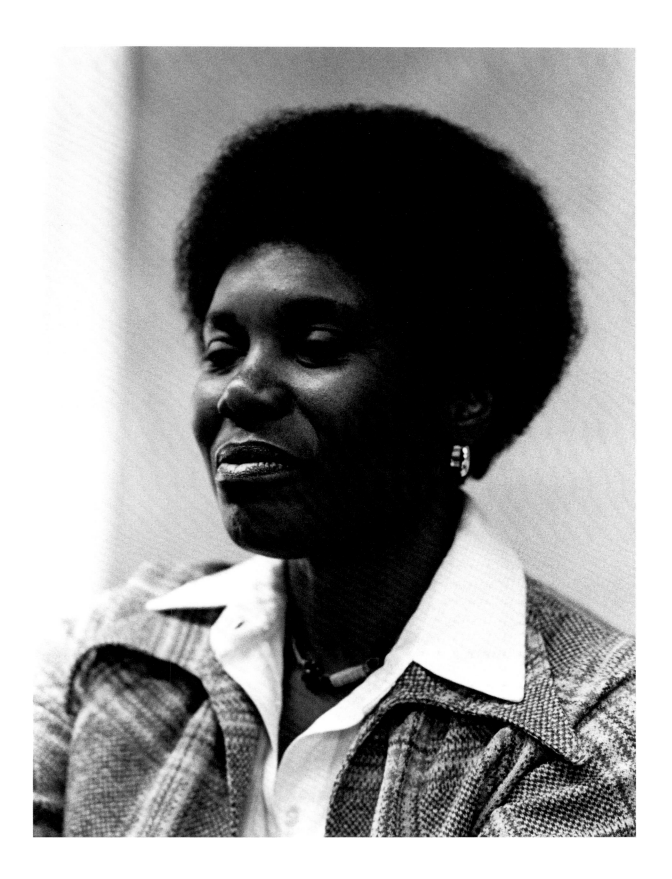

Colleen J. McElroy

"Monologue for Saint Louis," the opening poem of Colleen J. McElroy's *Queen of the Ebony Isles* (1984), interrogates the meanings of "home" and "stranger." Childhood memories of succulent "pockets of grapes" jostle with images darker than the green that stained the lips and fingers of eager grape-eaters. This volume, which won the American Book Award, is relentless in its pain, unsparing in its anger, unstinting in its images.

"Bone Mean" details a mother whose specialty was cruelty, who accepted nothing less than total surrender, who would " . . . stalk a single cockroach / ferreting on point until the crusty brown / body lies belly up." In "Ruth," a mother's fall down twenty-seven stairs is brushed around the edges with a filigree of guilt—as if the rebellious sixteen-year-old's furious wish for revenge against her mother's hurtful tyranny had been deliberately enacted: "one moment you were larger than life / your black arms spread like the wings / of some great vulture the next a step / missed and you fragile distorted plunging / in wingless flight." Even "Against a Winter of Dreams," dedicated to a friend dying of cancer, is burdened with the poet's overwhelming sense of embittered childhood grief: "I have grown to believe all winters / are full of the molting smells of pain." Even the quiet anguish of the more public poems, such as "The Point of No Return," seems drenched in a sorrow personal as well as historical: "when Equiano's black face turned west / his shackles clanged like bells."

The poems in *Bone Flames* (1987) often pivot around water and travel imagery, recalling at times the particulars of Middle Passage. In "Learning to Swim at Forty-Five," the casual cruelty of camp swim instructors connects the poet to ancestral memory: "full of the first primal fear / Of uncurling from the water belly of a mother country." The nautical imagery in the poem "To Market, to Market" also prefigures the wondrous travel writing that McElroy embarked upon years later: "at ten I almost knew how fish could hold a deep-seated / sense of magic despite man's prehistoric dread / of salty graves and red tides . . . / even then I had a strange need for the smelly magic of the sea, its fruit and tides—water singing of countries yet to be tasted."

A Long Way from St. Louie (1997), the first of McElroy's travel books, is "not a description or tour guide," as she explains, "but rather impressions of journeys, memories held in fragments." This is evident in her remembrance of photographing fish in the Coral Sea: "Bright yellow butterfly and angel fish billowed around my legs until it looked as if I were wearing a ballroom skirt. It was better than dancing at the prom." McElroy's research in ethnolinguistic patterns of dialect differences and oral traditions facilitated her second travel book, *Over the Lip of the World: Among the Storytellers of Madagascar* (1999).

Colleen J. McElroy teaches at the University of Washington in Seattle, Washington. The author of nine volumes of poetry, including *What Madness Brought Me Here: New and Selected Poems, 1968–1988* (1990) and *Travelling Music* (1998), she has also written a play, filmscripts, and the choreopoem *The Wild Gardens of the Loup Garou*, coauthored with Ishmael Reed. Her other major works include two short fiction collections, *Jesus and Fat Tuesday* (1987) and *Driving under the Cardboard Pines* (1990), which contains the science fiction riff "The Simple Language of Drones."

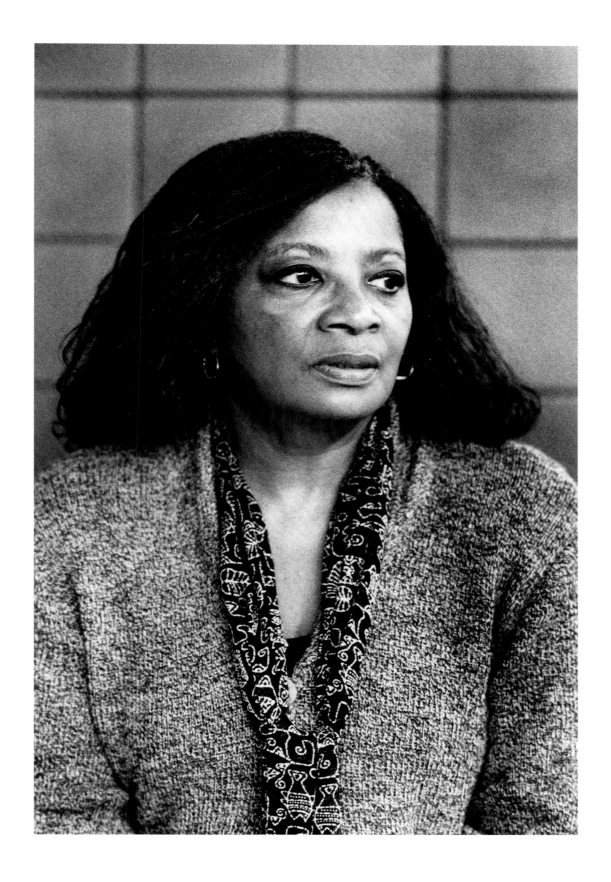

Toni Morrison

The narrator of Toni Morrison's *Jazz* wryly observes of her chosen endeavor, "Risky, I'd say, trying to figure out anybody's state of mind. But worth the trouble if you're like me—curious, inventive and well-informed." It is this contrary, "unreliable" revising, complex narrative mind that delivers the goods in all of Morrison's highly nuanced, irreducible, eloquent, demanding, fructifying fiction.

Nobel laureate Toni Morrison has described the function of language as akin to what a preacher should do: "make you stand up out of your seat, make you lose yourself and hear yourself." "My work bears witness," she insists. "[It] suggests who the outlaws were, who survived under what circumstances and why. . . . It's the complexity of how people behave under duress that is of interest to me."

The Bluest Eye (1970), exploring destructive ideas about physical beauty, delineates the territory of the struggle for the black writer to refute the imperious white text with its inherent untruthfulness for black lives. *Sula* (1974) interrogates the complexities of maternal love, World War I's aftermath, and symbiotic friendship. *Song of Solomon* (1977), a novel about Milkman's search for self, for story, is a parable about the naming, flight, and ancestors, in which giving voice is not so important as what you give voice to. Assisting in disemboweling a bobcat, Milkman is told by the old black hunters not to go after what is merely the sound and the fury, but to go after what is essential: "don't get the lungs now. Get the heart." *Tar Baby* (1981) is an allegory about colonialism and authenticity, a man who has not forgotten his "ancient properties" and a woman in flight from them, and Valerian Street, willfully "guilty . . . of innocence."

Pulitzer Prize–winning *Beloved* (1987) is a meditation on loving, the contours and possibilities and beauty of love. Densely textured, visual, and cinematic in its onrush of simultaneous images and memories—Biblical, mythological, Native American, archetypal, those evoking Middle Passage, and the magical/supernatural—the structure of this fictional slave narrative emulates the patterns of memory: disjointed, circular, insistent, urgent. In moments in which Sethe is unable to disremember, the primal images of the novel, unwilled and unbidden, flood her: Schoolteacher's ink, the theft of Sethe's breast milk, Paul D's neck jewelry, iron bits, the underground cages of Alfred, Georgia, the ironic beauty of Sweet Home, Halle's buttered face, and the crisping of Sixo.

Each character in *Jazz* (1992), a polyrhythmic, percussive masterpiece about "the dirty, get-on-down music [that] . . . made you do unwise disorderly things," enacts an improvisational solo performance, an accompaniment to the Narrator's—and the City's—melody. Morrison's most recent novel, *Paradise* (1998), is situated in all-black Ruby, Oklahoma, a community which insulates its inhabitants from "Out There where every cluster of whitemen looked like a posse."

Toni Morrison was born Chloe Anthony Wofford in 1931 in Lorain, Ohio. The author of a play, *Dreaming Emmet*, and the study *Playing in the Dark: Whiteness and the Literary Imagination* (1992), she was a senior editor at Random House and is now the Goheen Professor of Humanities at Princeton University. This photograph was taken in Berkeley in 1987.

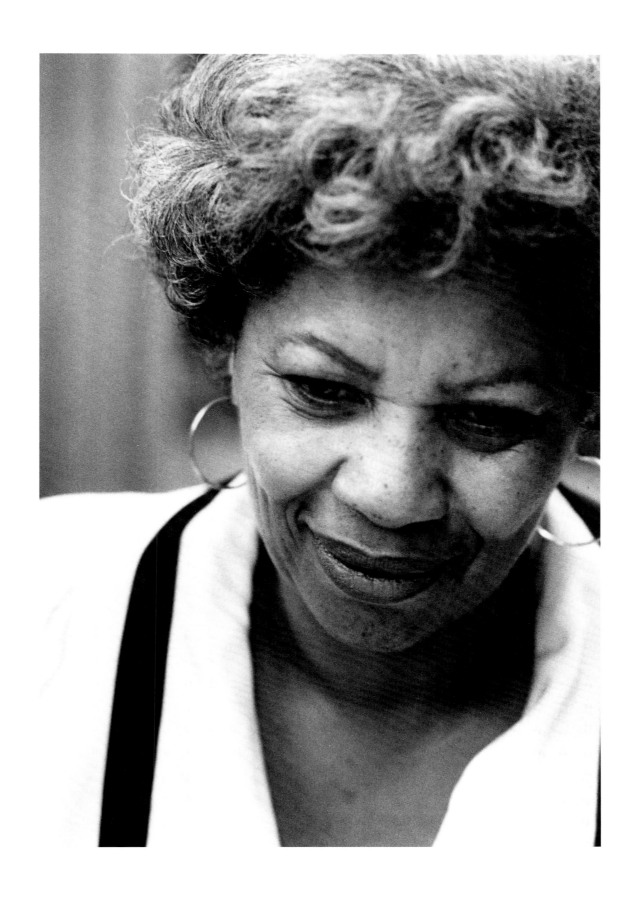

Walter Mosley

Probably best known for the Easy Rawlins novel *Devil in a Blue Dress* (1990), later made into a film starring Denzel Washington, Walter Mosley has published five other novels narrated by Ezekiel (Easy) Rawlins, detective by circumstance more than by training: *A Red Death* (1991), *White Butterfly* (1992), *Black Betty* (1994), *A Little Yellow Dog* (1996), and *Gone Fishin'* (1997). Writing in the tradition of Chester Himes, Mosley creates a hero in this detective fiction who is a modern day tribal elder, a resolver of community disputes "that would otherwise come to bloodshed." As Mosley himself points out, "the genre may be mystery, but the underlying questions are moral and ethical, even existential." In *Always Outnumbered, Always Outgunned* (1997) and *Walkin' the Dog* (1999), a new character, Socrates Fortlow, a troubled ex-convict, steps into the spotlight. Just as ancestor spirits guide Easy in the wisdom imparted by "the voice," who instructs him on how to "survive like a man," Socrates—"a prisoner-in-waiting on the streets as far as the cops were concerned"—survives in this gritty South Central Los Angeles neighborhood partly because of his belief in the angel his aunt Bellandra describes, sent "to save black mens from fallin' out the world complete." Socrates' lethal self-defense against a young mugger's brutal attack leaves him reeling with self-doubt and anger, but also deeply reflective.

Mosley's most stunning accomplishment, however, is *RL's Dream* (1995), which ties small bits of blues history together with the loose threads of an old man's tale. Soupspoon Wise, a bluesman near the end of his long life, dwells in the memories of his brief but glorious association with the legendary blues master Robert Johnson. Soupspoon finds unlikely mercy and recognition with the help of Kiki, a white women with her own host of problems. It is Kiki who arranges for Soupspoon to get illegal health insurance, and once the doctors discover what Soupspoon already knew, that cancer was claiming him quickly, it is Kiki who reunites him not only with his estranged wife, but also with the music that so consumed him there was hardly room for another love. Soupspoon's memories provide Mosley with an evocative narrative device, fusing two stories, two communities, one spirit of resistance. One of four hundred people at the funeral of a young white man who has died of AIDS, Soupspoon jump-cuts to an earlier memory. When his boyhood friend Jolly died as a result of a racist boss's whim, a thousand people gathered at the funeral vigil—a community protest that also evokes in readers memories of similar black vigils in places like Soweto and Johannesburg.

Born in Los Angles in 1952 and currently a resident of New York, Walter Mosley is the author of the science fiction novel *Blue Light* (1998); two nonfiction political works, the anthology *Black Genius: African American Solutions to African American Problems* (1999) and *Workin' on the Chain Gang: Shaking off the Dead Hand of History* (2000), which explores the relationships among oppression, capitalism, and racism; and a forthcoming novel, *Fearless Jones* (2001). This photograph was taken at A Clean Well Lighted Place for Books in San Francisco in 1999.

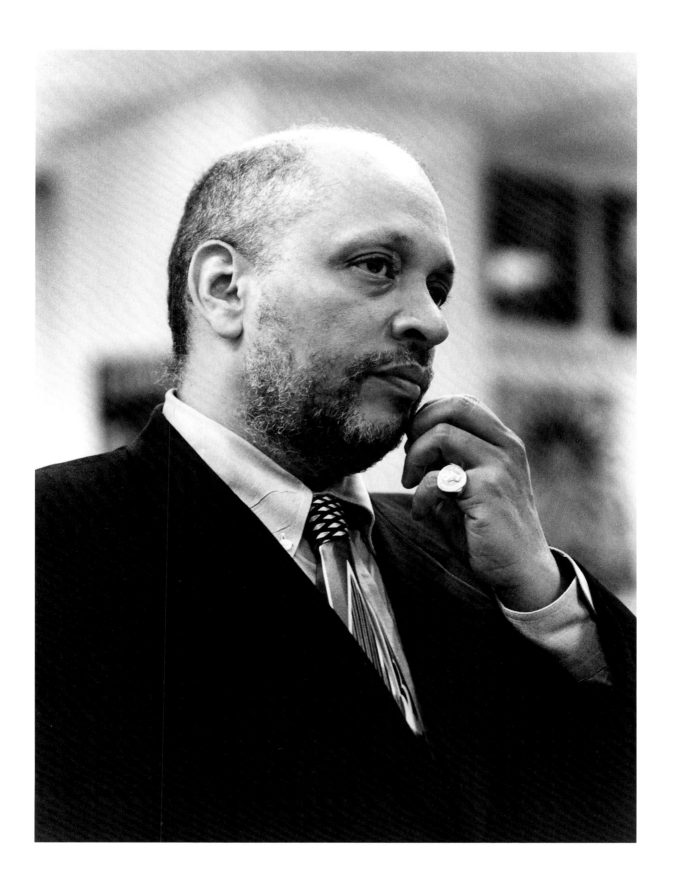

Harryette Mullen

The final quatrain of Harryette Mullen's most recent volume of poetry, *Muse & Drudge* (1995), begins with the injunction to "proceed with abandon," instruction this profoundly experimental, inventive poet has followed throughout her literary career. Mullen's attention to the function of language to excavate and reveal cultural attitudes identifies her as a language poet, but one with a specifically African American context. Her rhythm derives from twelve-bar blues, and the poems overflow with images of hot combs, gumbo, jellyroll, Ashanti, Dahomey, Orisha, ragtime, jitterbug, and irreverent references to canonized black texts: "up from slobbery" and "the soles of black feet." In Mullen's hands, the slightest alteration of words produces a powerful alternate American history: star-spangled banner becomes "stark strangled banjo," the white collar criminal of corporate America is echoed in a female and black "pink collard criminal."

Mullen's essay "African Signs and Spirit Writing" borrows from art historian Robert Farris Thompson, in suggesting how the voice in such African and diasporic musical forms as jazz, scat singing, field hollers, and gospel wails "may be 'unshackled' from meaningful words or from the pragmatic function of language as conveyer of cognitive information." This essay offers an important insight into Mullen's own impulse to "[drift] between intentional utterance and improvisational wordplay, between comprehensible statements and the pleasures of sound itself." The narrator of her prose poem "She Swam on from Sea to Shine" could well be speaking of Mullen's literary methodology: "More paper, more pencils, more writing, she went everywhere she could. She went on a whim, on a limb, she whimpered. She

slowed down, she settled, she got stuck. She came loose, she mended. She came undone, she repaired herself again. She shook her groove thing and got it on."

Mullen's more traditional *Tree Tall Women* (1981) was followed by *Trimmings* (1991), a title suggesting both decorations and cast-offs. The poems engage in a dialogue with Gertrude Stein's *Tender Buttons* and proceed, as Mullen explains, "metonymically and associatively, from women's clothing to women's bodies." A woman in a semiformal gown is described as "frilled to the bone," an image of woman as commodity, an expensive extravagance, a rack of lamb all dolled up before being consumed. The term "boning"—slang for both sexual activity and the whalebone stays in women's corsets—is evoked as well.

*S*PeRM**K*T* (1992) investigates the language of food packaging, advertising, shopping, and shelf appeal. The American obsession with cleanliness, associated with whiteness, is satirized in invented words like "chlorinsed" and "disinfunktant"—the latter evoking Toni Morrison's character Geraldine, obsessed with eradicating the funkiness of life. A poem in which the dead bodies of roaches "crunch like candy" after being poisoned explores the trope of insect extermination as racial genocide, an idea similarly explored in poems by Audre Lorde and Lucille Clifton.

Born in Florence, Alabama, Harryette Mullen currently teaches at the University of California, Los Angeles, and is the author of *Freeing the Soul: Race, Subjectivity, and Difference in Slave Narratives* (1999) and the forthcoming prose poems, *Sleeping with the Dictionary.* This photograph was taken at the San Francisco Book Fair in October 1999.

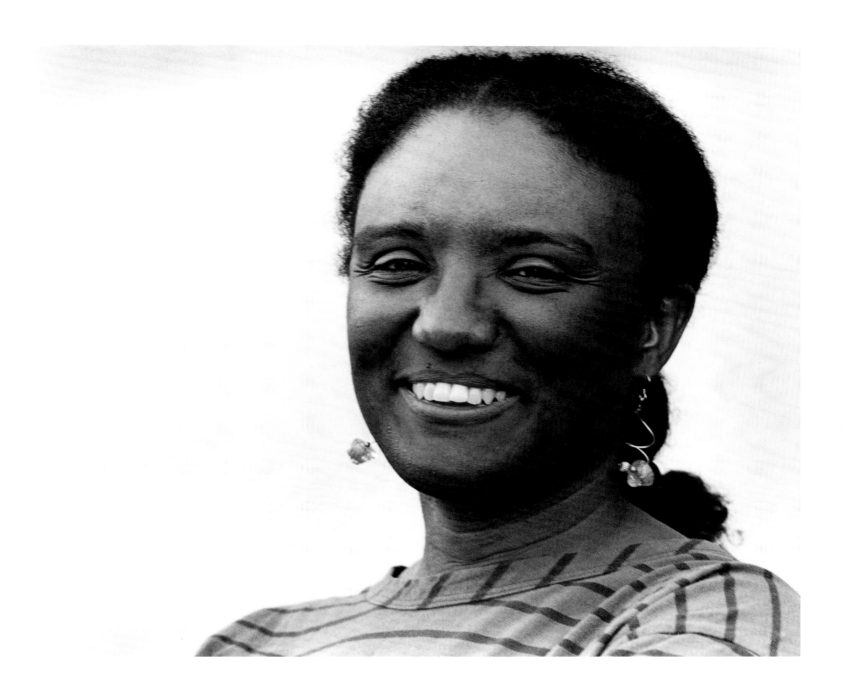

Albert Murray

Born of the same generation, Albert Murray is the spiritual twin and published correspondent of Ralph Ellison. Like Ellison, Murray grew up in the South, went to Tuskegee, wrote influential works on jazz and the blues, and experienced black life in America as a cornucopia of life-affirming acts. Like Ellison, Murray drank deeply from the wellspring of European modernism and made his mark as a novelist and essayist. But unlike Ellison, whose greatest fame preceded the Black Power movement of the '60s, Murray announced his arrival on the literary scene at the age of fifty-four with a stunningly controversial collection of essays, *The Omni-Americans* (1970), contradicting what he terms "the folklore of white supremacy and the fakelore of black pathology."

The linguistic playfulness of the formulation is characteristic of a style that could swing from the rigorously academic (*The Hero and the Blues* [1973]) to the be-bop of his novels and informal essays. Here is a description of a pendulum clock adorning the boyhood home of Murray's fictional persona in the first of his trilogy of novels, *Train Whistle Guitar* (1974): "[I]t ticked and tocked and ticked and tocked and tocked and struck not only the hours but also the quarter-hours with the soft clanging sound you remember when you remember fairy tale steeples and the rainbow colors of nursery rhyme cobwebs; because it hickory dickory docked and clocked like a brass spoon metronome above the steel blue syncopation of guitar string memories; because it hocky-tock rocked to jangle like such honky tonk piano mallets as echo midnight freight train distances beyond patch-quilt horizons and bedside windowpanes."

Such swooping English is only to be expected from an author who championed the blues as the great gift of American Negroes (as he termed them) to themselves and to the world; according to Murray, the bluesman and -woman are the heroes of black culture. As novelist he recast his own life in a heroic mold through the autobiographical fiction of *Train Whistle Guitar*, *The Spyglass Tree* (1991), and *The Seven League Boots* (1996).

Borrowing a leaf from T. S. Eliot, Murray advocates a blending of individual experience with the models provided by the Great Tradition. As he writes in *The Hero and the Blues*: "[T]he most valid aspiration as well as the much urgent necessity for any writer who truly takes the social, which is to say the ethical, function of fiction seriously is . . . to achieve something natural to himself and to his sense of life, namely a stylization adequate to the complexity of the experience of his time and place—and perhaps with the luck of past masters, something more than merely adequate."

Murray was born in Nokomis, Alabama, in 1916. Poet, blues writer, essayist, he is the author of *Stomping the Blues* (1976), *South to a Very Old Place* (1971), *The Blue Devils of Nada* (1996), and (with Count Basie), *Good Morning Blues: The Autobiography of Count Basie* (1985). This photograph was taken at Albert Murray's home in Harlem in March 2000.

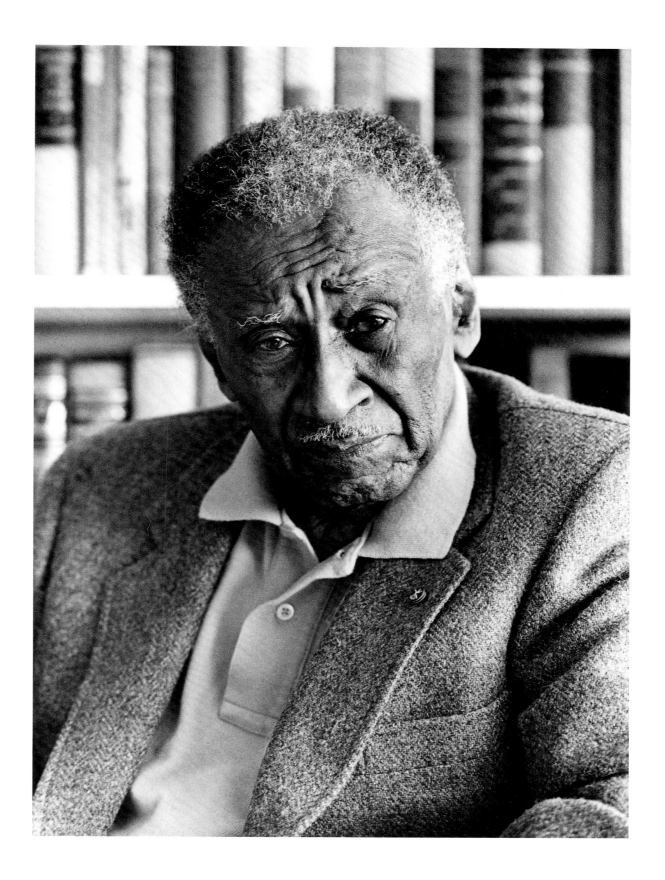

Gloria Naylor

With her ability to inhabit the minds of welfare mothers, would-be revolutionaries, weak fathers, lesbians, soul-destroyed strivers, gay men, and, above all, a multiplicity of women who cope and heal, Gloria Naylor has placed permanent fictional geographies—a decaying urban project (*Brewster Place*), a middle-class housing development (*Linden Hills*), a magical island off the Atlantic coast (*Mama Day*)—onto the American literary landscape. With its human interest, poetic realism, and dramatic use of pitch-perfect dialogue, Naylor's fiction instantly hit home. She burst on the scene in 1982 with *The Women of Brewster Place*, a bestseller which won the American Book Award and was subsequently made into a television movie. Her popular and literary success stems from a style which references both the quotidian reality of people's lives and the seductive use of metaphor. Here, for example, is how she describes the dawning recognition that the two new tenants of Brewster Place are lesbians: "The smell had begun there. It outlined the image of the stumbling woman and the one who had broken her fall. Sophie and a few other women sniffed at the spot and then, perplexed, silently looked at each other. Where had they seen that before? They had often laughed and touched each other—held each other in joy or its dark twin—but where had they seen *that* before? It came to them as the scent drifted down the steps and entered their nostrils on the way to their inner mouths. They had seen that—done that—with their men. That shared moment of invisible communion reserved for two and hidden from the rest of the world behind laughter or tears or a touch."

Although Naylor quickly took her place among them, she sees herself as the daughter of writers Toni Morrison, Alice Walker, and Paule Marshall, whose achievement and "gorgeous language" allowed her to believe that African American women could indeed write books. Nonetheless, as she stated in a 1991 interview, "I learned about language and how to discriminate in my reading through the English classics. I was not taught any book by or about black Americans." This familiarity with the Western canon has enriched her writing through its intertextual engagement with such writers as Shakespeare (*Mama Day*) and Dante (*Linden Hills*).

Gloria Naylor was born in Queens, New York, in 1950. *The Women of Brewster Place* headed a trilogy which also included *Linden Hills* (1985) and *Mama Day* (1988). Her other novels are *Bailey's Café* (1992), set in Brooklyn, and *The Men of Brewster Place* (1998). She lives in New York, is involved in a literacy program in the Bronx, and has founded an independent film company, One Way Productions. This photograph was taken at Cody's Books in Berkeley in 1988.

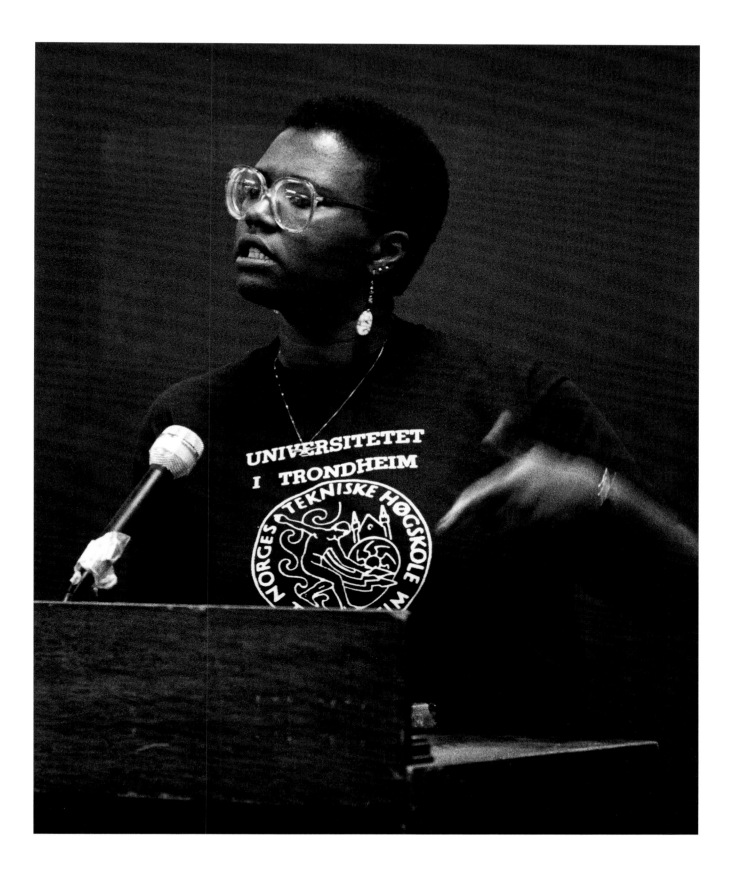

Barbara Neely

Barbara Neely brings detective fiction up to date with the wise, witty, socially aware, take-no-prisoners, Blanche White, a very dark-complexioned African American woman, whose intuition and general curiosity combine to make her an accomplished amateur detective. Neely's serial protagonist is a domestic by profession. Vacationing at Amber Cove, a resort for well-to-do blacks, she observes the color-struck attitudes of the "Insiders": "as hincty a bunch of Talented Tenths as you'd ever want to see." Hypocrisy, classism, arrogance, homophobia, sexism, and myths of physical beauty in black families as well as white receive her scathing social critique.

In her first novel, *Blanche on the Lam* (1992), winner of the Agatha, Macavity, and Anthony awards, Neely provides Blanche with the opportunity to deconstruct shallow arguments about how much the world has changed in the last fifty years: "Nowadays, people wanted to tell you class didn't exist and color didn't matter anymore. Look at Miss America and the chairman of the Joint Chiefs of Staff. But Miss America and the chairman were no more black people than Mother Teresa was white people. Men like Nate and women like her were the people, the folks, the mud from which the rest were made. It was their hands and blood and sweat that built everything."

In *Blanche Cleans Up* (1998), Blanche finds herself filling in at the home of Mr. Brindle, who is running for governor. Working in Brindle's house Blanche rubs elbows with people she would gladly avoid: "Blanche was generally delighted to come across a group of black people, but her stomach dropped when she saw that the *They* Brindle had referred to were what she called The Downtown Leadership—the black men that the big downtown whitefolks talked to when they needed blacks with positions and titles to support the latest cut in programs for the poor, or to amen some closet racist like Brindle." In this novel, as in her others, Blanche is compassionate but entirely sharp-eyed at the coping strategies of young black people, describing young rappers as "bunches of boys in dreds with their pants hanging off their butts rapping about what bitches black women were," her adopted daughter Taifa as "bilingual" because she has acquired the language of ghettospeak, and the drug-selling Pookie as "just trying to be exactly what America told him he was: everybody's worst nightmare." Neely's Blanche White series also includes *Blanche Among the Talented Tenth* (1994) and *Blanche Passes Go* (2000).

Born in 1941, Barbara Neely holds a master's degree in urban and regional planning from the University of Pittsburgh and also writes short fiction. A community activist, she served for many years as the director of Women for Economic Justice and now co-chairs its board of directors. She was a founding member of Women of Color for Reproductive Freedom. She lives in Jamaica Plain, a suburb of Boston. This photograph was taken in June 2000 at a reading at the National Women's Studies conference at Simmons College in Boston.

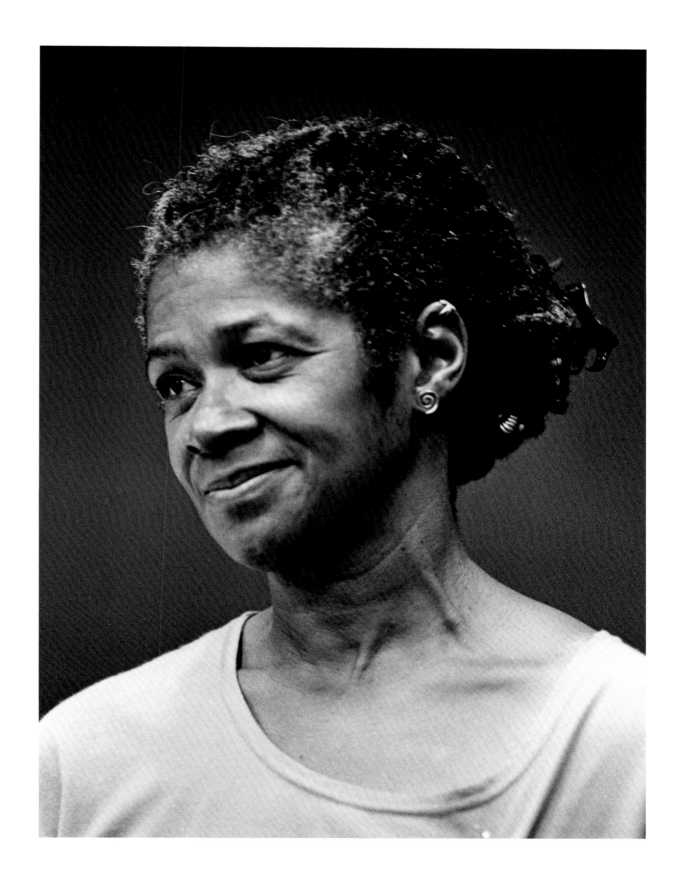

Pat Parker

Blunt, courageous, uncompromising, humorous, willing us with her words to defeat within ourselves the things that divide us, Pat Parker has been above all a poet of community. Writing out of an oral tradition, in ordinary language, she demanded accountability: "Brother / I don't want to hear / about / how *my* real enemy / is the system. / i'm no genius, / but i do know / that system / you hit me with / is called / a fist," and "SISTER! Your foot's smaller, / but it's still on my neck." She celebrated and valorized black women's lives, lesbian lives, working class lives. Refusing the schism between the political and the personal, she wrote unabashedly autobiographical poetry, and with her words, she invited those who had been taught that their lives were not the stuff of poetry to love themselves. In the process, she also encouraged many of us to love poetry, too.

The archetypal image of a woman as midwife at her own birth finds its representation in the opening poem of Parker's *Child of Myself* (1972), which blasts the Genesis myth of Eve taken from Adam's rib. In no longer claiming "a mother of flesh / a father of marrow," Parker metaphorically gives birth to herself and becomes a poet, a truth-teller. Writing about the murders of black children in Atlanta, she titled a poem with the bitterest irony, "georgia, georgia, georgia on my mind." In the title poem of *Womanslaughter* (1978), the poet describes the murder of her sister Shirley at the hands of Shirley's ex-husband. Parker names this a communal act of male violence and announces her allegiance to all women, warning, ". . . if one is beaten, / or raped, or killed, . . . / I will come with my many sisters / and decorate the streets / with the innards of those / brothers in womanslaughter." Her love, however, was as legendary as her anger, as wit-

nessed by the evocative poem about her first meeting with poet Audre Lorde, "an ebony meteorite / that will pierce / into your darkness / illuminate your fears / hurl them at you / laughing."

Born in Houston, Texas, in 1944, Pat Parker also published the poetry collections *Pit Stop* (1974), *Movement in Black* (1978), and *Jonestown and Other Madness* (1985). Her political activism took many forms, including involvement with the Black Panther Party, the Black Women's Revolutionary Council, the Women's Press Collective, and a nine-year tenure as medical coordinator at the Oakland Feminist Women's Health Center. Parker died of breast cancer in 1989. This photograph was taken in Albion, California, at the first Country Women's Festival in 1972.

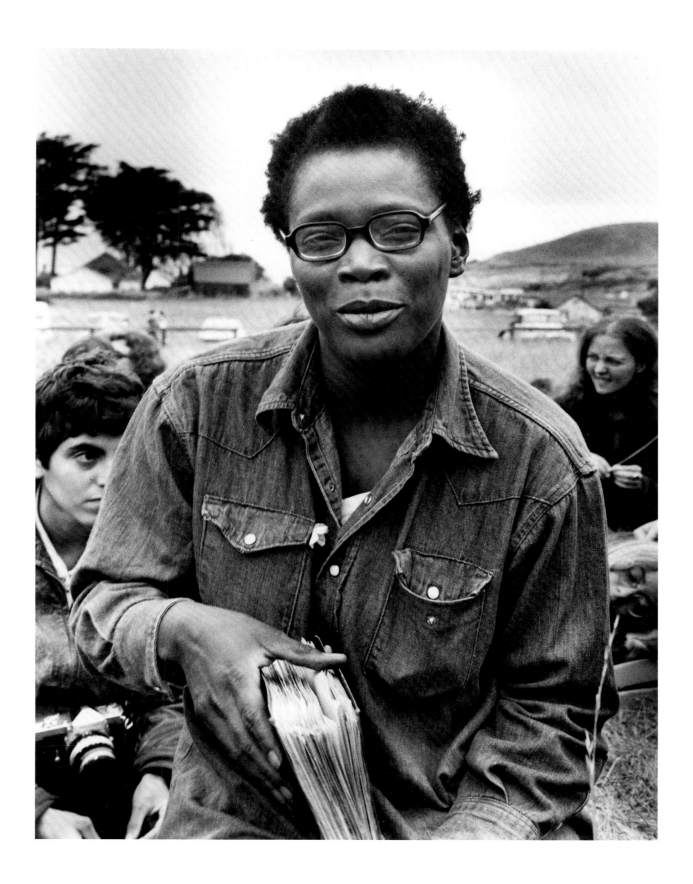

Ishmael Reed

Ishmael Reed—novelist, poet, essayist, playwright, editor, libretto writer, and master of satire, hyperbole and invective—compares himself to legendary bluesmen Charles Mingus and Charlie Parker, ("musicians who have a fluidity with the chord structure just as [writers] have with syntax or the sentence which is our basic unit,") and to the collage impulse in equally legendary artists Betye Saar and Romare Bearden. Reed accurately describes his own style as like gumbo, "an original conception [offering] the possibilities of exquisite and delicious combinations." His fictive discontinuities do in fact resemble jazz, collage, and the culinary arts, for in all of these, a harmonious whole can be obtained from elements and associations which initially appear discordant. Indeed, African American cowboy Loop Garoo in *Yellow Back Radio Broke-Down* (1969) insists that "a novel can be anything it wants to be, a vaudeville show, the six o'clock news, the mumblings of wild men saddled by demons."

Reed has developed an insightful, knowledgeable, and far-reaching commentary on history, race, African mythology, and American culture. The Yoruba god Legba shows up as "obeah-man" PaPa LaBas in *Mumbo Jumbo* (1972), a detective novel satirizing European high art, celebrating instead "low-down, gut-bucket music," "hully-gullying" dance, and "niggers writing. Profaning [white people's] sacred words . . . putting their black hands on them so that they shine like burnished amulets." The range of Reed's fiction is reflected in his borrowing from the social realism of artist José Orozco's murals in *The Terrible Twos* (1982) and his populating *The Last Days of Louisiana Red* (1974) with 1950s television characters Amos, Andy, and Kingfish.

Despite its hilarious anachronisms (broadcasting Lincoln's assassination on television and providing fugitive slave Raven Quickskill with a Jumbo jet), *Flight to Canada* (1976) explores with great seriousness many themes of central importance to African American literature. Repudiating a traditional amanuensis, the novel opens with its own self-authenticating device: Quickskill's poem. The novel explores the Dred Scott decision, President Lincoln's support of the Fugitive Slave Law, the existential meaning of freedom ("He preferred Canada to slavery, whether Canada was exile, death, art, liberation, or a woman"), the false attribution of white literary ancestors to black writers, and the theft of actual slave narratives like those of Josiah Henson and Nat Turner by writers Harriet Beecher Stowe and William Styron ("taking [a man's story] is like taking his gris-gris").

Ishmael Reed is the author of four collections of essays as well as five collections of poetry. *Conjure: Selected Poems 1963–1970* (1972) includes Reed's famous "Neo HooDoo Manifesto" and "I am a cowboy in the boat of Ra," which invokes Blake, Yeats, Whitman, Milton, Homer, and the great jazz saxaphonist Sonny Rollins. The Egyptian myth of conflict among the gods Osiris, Horus, and Set is retold here as a new kind of Western: a gunman "vamoosed from / the temple," whose words are bullets, whose "mouth's / shooting iron got its chamber jammed." His most recent novel is *Japanese by Spring* (1993), a satire on academia.

Winner of both MacArthur and Guggenheim fellowships, Ishmael Reed was born in 1938 in Chattanooga, Tennessee, grew up in Buffalo, New York, lives in Oakland, and lectures at the University of California, Berkeley. This photograph was taken at Cody's Books in Berkeley in May 2000.

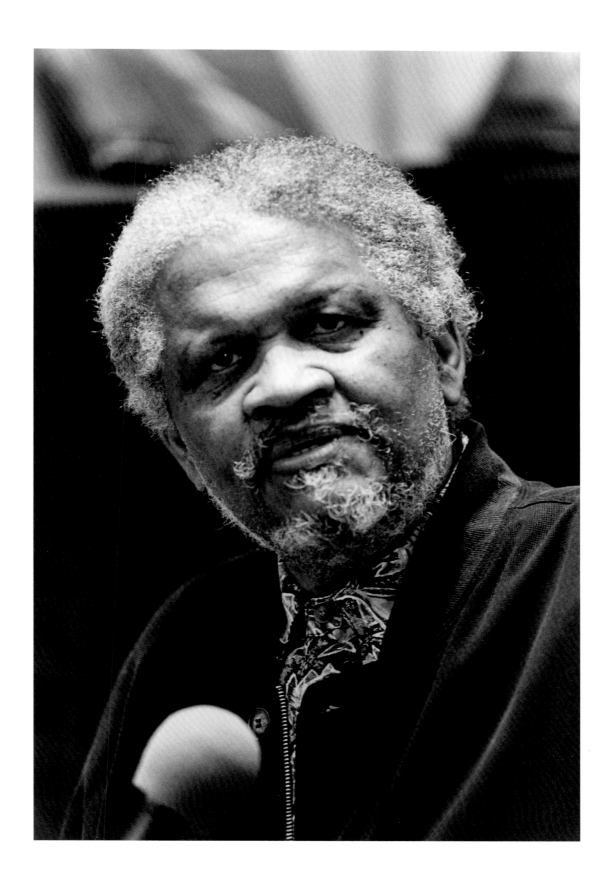

Faith Ringgold

Faith Ringgold, quilt artist, sculptor, painter, autobiographer, and author/illustrator of children's books, combines the arts of storytelling and quiltmaking, writing in the margins and at the hems of her "story quilts." With these deeply personal and profoundly political creations, she repudiates the traditional demarcations between the visual and the textual. From Harriet Powers's nineteenth-century African American Story Quilt and before to the NAMES Project AIDS Memorial Quilt and beyond, a dynamic tradition of quiltmaking has reflected joy and anger, visions and possibilities. In this tradition, Ringgold uses African aesthetics and textiles, African American folklore and iconography, to explore through word and image the central tropes of black life.

Some of Ringgold's quilts are expressions of optimism and celebration. *Who's Afraid of Aunt Jemima*, an acrylic on canvas story quilt, is a visceral response to the social denigration of large black women and a reclamation of the positive aspects of the stereotype. The text in this creation animatedly recounts the story of Jemima Blakey, a spirited young woman, who chooses her husband over her parents' disapproval and becomes independently wealthy working for the Prophet family, "cookin, cleanin and takin care a they chirrun." Ringgold's quilt *Tar Beach* depicts a nighttime family picnic on a Harlem rooftop. With stars and windows twinkling in the distance, third-grader Cassie Louise Lightfoot wears the lights of the George Washington Bridge "like a giant diamond necklace" and joyously insists, "Anyone can fly. All you need is somewhere to go that you can't get to any other way." Ringgold subsequently wrote and illustrated a children's book based on the quilt. The book *Tar Beach* won numerous honors, among them the Coretta Scott King Illustrator's Award.

Other more political quilts record horror and demand accountability. In the unsettling *Flag Story Quilt*, an armless, paraplegic African American veteran is falsely charged with rape and murder, the text in the margins protesting, "How he gonna slash some girl's throat and throw her in the Harlem river, and he ain' got no arms?" *Matisse's Chapel* depicts generations of a black family gathered in the chapel challenging a white descendant of slave owners, "'bout your funky hands. I hopes you get them clean real soon. You is right. They do smell bad."

Faith Ringgold is the author of *We Flew over the Bridge: The Memoirs of Faith Ringgold* (1995) and *Aunt Harriet's Underground Railroad in the Sky* (1992), a children's book which borrows the motifs of the flying African and the quilt as an emblem of shelter, survival, freedom, and hope. Her other children's books include *Dinner at Aunt Connie's House* (1993), *My Dream of Martin Luther King* (1995), *Bonjour Lonnie* (1996), *The Invisible Princess* (1998), and *If a Bus Could Talk: The Story of Rosa Parks* (1999).

Born in Harlem in 1930, Faith Ringgold has received a Guggenheim Fellowship and two National Endowment for the Arts Awards. This photograph was taken in April 2000 on the campus of University of California, San Diego, where Ringgold is a professor of art.

Kalamu ya Salaam

Kalamu ya Salaam credits his grandfathers—both preachers—for his oratorial inheritance and his family for his commitment to his community. A native of New Orleans, he enriches the life of his community as a performance poet, playwright, fiction writer, arts administrator, literary interviewer, music and cultural critic, radio show host, editor, publisher, and essayist.

What Is Life? Reclaiming the Black Blues Self (1994) collects Salaam's wide-ranging essays (on topics from loneliness to the blues aesthetic) and "Sun Songs," poems that carry the torch of celebration. In "Sun Song XIII" ("Be About Beauty"), the poet gently admonishes: "Be about beauty / As strong as a flower is /Yet as soft too / . . . Be about beauty / No matter life's dirt / Be about beauty." Salaam's early poetry actively engaged the Black Arts movement, often foregrounding and building from the work of his contemporaries. In his 1973 volume, *Hofu Ni Kwenu/My Fear Is for You*, Salaam sides with Amiri Baraka on the nature of division in the black family and quotes Haki Madhubuti's argument "a continuous re-assertion of a European individualism vis-a-vis man and woman inadvertently has made us antagonists." Salaam's work attempts to heal this gendered rift in the community. In "Letter to My Sisters," Salaam encourages women to find and celebrate their natural beauty: "consider yourself my sister / & the / womanly image / you can make by / being yourself." The 1976 volume *Ibura* focuses on the struggle of black women within the Black Arts movement. His best-known poetry collection is *Revolutionary Love* (1978).

Salaam's early plays focused on the issues that he saw black people dealing with on a daily basis. His working relationship with the Free Southern Theater allowed him to produce many of his plays as he was composing them, including *Mama* (1969), *Black Liberation Army* (1969), and *Homecoming* (1970). In his 1993 play *Malcolm, My Son*, Amina and her gay son Malcolm try to reconnect after Malcolm has been away at college.

Critic Jordan Green has referred to Salaam as "a poet of maroon guttiness and holy daring." Salaam has certainly drawn heat for his literary populism, for insisting that a movement away from accessibility excludes many people who need to have a cultural representation of their own reality.

Salaam is the founder of Runagate Press and NOMMO Literary Society, leader of the performance poetry ensemble WordBand, poetry editor for *QBR Black Book Review*, and moderator of the listserv e-Drum. He is the author of *The Magic of Juju: An Appreciation of the Black Arts Movement* (1998), the editor of the anthology *360°: A Revolution of Black Poets* (1998), and the creator of the spoken word CD "My Story, My Song."

Born Vallery Ferdinand III in 1947, he later claimed the name Kalamu ya Salaam, Swahili for "Pen of Peace." This photograph was taken in Salt Lake City, Utah, in October 2000 at the AALCS conference, "Looking Back with Pleasure II."

Sonia Sanchez

When fiery Black Arts poet Amiri Baraka called for "assassin poems, Poems that shoot / guns," poet Sonia Sanchez readily supplied revolutionary ammunition. In "For Unborn Malcolms" her outrage at white violence urges simple, direct, violent retaliation: " . . . us blk / niggers / are out to lunch / and the main course / is gonna be . . . white meat."

Sanchez's response to those offended by her use of "obscene" language was to denounce what she saw as the true obscenities of the time: "Ca / PITA / LISM / blk / pimps / nixonando / COMMUNISM. / missanne / rocke / FELLER." The poem's anger is reflected in aggressive typography: a mix of all capitals and all lowercase words, studded with frequent diagonal slashes, words strung together to suggest a correlation between the politics of Nixon and the politics of slave mistresses, between the economic greed of white corporations and black street hustlers. In "Blk/Rhetoric," a defiant distress signal, Sanchez demands that victimology and rhetoric be replaced with meaningful social change: "who's gonna give our young / blk / people new heroes / (instead of catch / phrases) / (instead of cad / ill / acs)." Throughout her career, Sanchez has been committed to social activism, to resolving the anger between black men and women, to community, to nation-building, to black studies, and to the peace movement, and these issues recur throughout her poetry, short fiction, children's books, and plays.

Her work also abounds with praise poems for such black heroes as James Baldwin, Toni Morrison, Johnnetta Cole, Bernice Reagon, John Coltrane, Sterling Brown, and Martin Luther King, Jr. In her first collection, *Home Coming* (1969), Sanchez honors Malcolm X, "the sun that tagged / the western sky." *We a BaddDDD People* (1970) contains the vibrant, celebratory "For Our Lady," in which Sanchez tells Billie Holiday: "no mo. / blues / trains running on this track / they all been de / railed. / am i blue ? / . . . no. i'm blk / and ready."

Sanchez describes her involvement with the Nation of Islam in her spiritual autobiography, *A Blues Book for Blue Black Magical Women* (1974), which contains the Queens of the Universe poems: "it ain't easy being a queen in this unrighteous world / . . . but we steady trying." Many of Sanchez's haiku love poems are suffused with the annealing joy and spiritual claim of black relationships: "Was it yesterday / love we shifted the air and / made it blossom Black?" Others are filled with plaintive despair: " . . . if / i had known you, i would have / left my love at home."

Sanchez's *homegirls & handgrenades* (1984) contains the extraordinary prose poem "Just don't Never give Up on Love," a story about a poet's chance encounter with a delightful griot of love and possibility, an eighty-four-year-old black woman.

Born Wilsonia Benita Driver in 1934 in Birmingham, Alabama, Sonia Sanchez won an American Book Award for *homegirls & handgrenades* in 1985. The Laura Carnell Professor of English and Women's Studies at Temple University, Sanchez lives in Philadelphia. This photograph was taken in Brooklyn at the National Black Writers Conference in April 2000.

Sapphire

Sapphire's many years of teaching reading to students in the Bronx and Harlem is reflected in her novel *PUSH* (1996), which won the First Novelist Award from the Black Caucus of the American Library Association. It is the story of Clareece Precious Jones's determined quest not just for language but for emotional literacy. A child whose life before now has consisted of repeated—and indescribably brutal—sexual, emotional, and physical abuse, Precious wonders, "What it take for my muver to see me? Sometimes I wish I was not alive. But I don't know how to die." Sixteen years old and mother to two of her own father's children, she discovers that she is HIV positive; her heart hammers in her chest cavity, and the old refuge of numbness beckons. Hope comes in the figure of Blue Rain, an extraordinary alternative school teacher, whose fierce belief in her students gently un-shames those inside the circle of her caring. Precious's will, not just to survive, but to survive whole, claims victory: "Ms. Rain say 'if you just sit there the river gonna rise up drown you! Writing could be the boat carry you to the other side.'"

Sapphire's *American Dreams* (1994) explores and exposes many of the same challenges Precious confronts: racism, abuse, incest, neglect, and invisibility. The unspeakable is told by those whose voices have almost never been heard in literature: fifteen-year-old Latasha Harlins, gunned down by a Korean grocer; a thirteen-year-old rapist, gone "wilding" in Central Park with his buddies; and a young girl raped by her father, her pelvis fractured, as a glistening puddle of blood "spread[s] from the broken bowl of [her] hips." The moments of compassion, healing, and empathy in this collection are all the more stunning for their unexpectedness. Sapphire

describes an abusive man, beaten himself as a child, as "trying to wrap barbed wire around the wind"; passion and caring transport two supposedly hardened women inmates to a "steamy paleolithic terrain."

Black Wings and Blind Angels (1999) continues this powerful mix of relentless anger and astonishing, hard-wrought compassion. In "Sestina" the poet wonders if a man's violence occurred because, like others of his race, gender, and generation, he "had about as much a chance of making it / as butterflies at Auschwitz." The devastation and beauty of "Broken," the closing poem in the collection, evokes Alison Saar's "Crossroads," a life-size sculpture of a powerful, courageous man in agony, his feet just above stacked firewood; inside the hinged, opening door where his heart would be are glowing embers: "I think everything in me has been broken. The shiny ceramic red heart lies on the floor in shards, its light that use to flash electric now glows steady in the dark. Outside the window I watch the souls of my mother and father wrapped in black shawls ride down the river. . . . I am here in my time, lit, broken, fire burning. . . . Vibrating, at last, light, life, mine. At last, broken."

Born in 1950 in Fort Ord, California, Sapphire lives in Brooklyn, where she earned an MFA at Brooklyn College. This photograph was taken in 1999 at the San Francisco Book Festival.

Ntozake Shange

Poet, playwright, novelist, essayist, cookbook author, actor, director, dancer, and installation artist Ntozake Shange describes what that enigmatic thing—a poem—can be: "quite simply a poem should fill you up with something / cd make you swoon, stop in yr tracks, change your mind, or make it up. a poem should happen to you like cold water or a kiss." Often her poems are precursors to choreopoems: intense, improvisational theatrical productions involving poetry, dialogue, and movement.

Toni Cade Bambara describes Shange's choreopoem *for colored girls who have considered suicide / when the rainbow is enuf* (1975) as "a comfortably loose strung series of portraits and narratives about women, black women. . . . Blisteringly funny, fragile, droll, and funky, lyrical, git down stompish, the play celebrates . . . the capacity to master pain and betrayals with wit, sistersharing, reckless daring, and flight and forgetfulness if necessary." Seven actresses fill Shange's stage with powerfully memorable lines, from "somebody almost walked off wid alla my stuff" to "i found god in myself / & i loved her / i loved her fiercely." Toussaint L'Ouverture "a blk man . . . / who refused to be a slave" and "sechita / egyptian / goddess of creativity" appear alongside the story of a Vietnam veteran who in a moment of hopelessness and rage drops his own children out of a five-story window.

Shange's "Program Note" (*See No Evil: Prefaces, Essays and Accounts, 1976–1983* [1984]) provides one powerful *raison d'etre* for her phonetic spelling, use of diagonals, variations in typography, syntax, punctuation, and capitalization: "i can't count the number of times i have viscerally wanted to attack deform n maim the lan-guage i waz taught to hate myself in." Shange's comments about her adaptation of *Mother Courage and Her Children* (1980) serve as a gloss on her entire *oeuvre*: "i am settling my lands with my characters, my language, my sense of right & wrong, my sense of time & rhythm." Shange's *A Daughter's Geography* (1983) recalls when "ellington was not a street / robeson no mere memory / du bois walked up my father's stairs" and contains the exuberant, sexually celebratory "From Okra to Greens" poems in which the speaker literally transforms her lover into mustard greens and collard greens and delightedly admits to having a "greens overdose." *Ridin' the Moon in Texas: Word Paintings* (1987) is a sensuous, unusual prose and poetry collection based solely on her response to the work of visual artists.

Shange's fiction, too, is evocative and lyrical, from the streets in Charleston that "wind the way old ladies' fingers crochet as they unravel memories of their girlhoods" and Uncle John's magical gift of a fiddle that "be callin' our gods what left us / be givin' back some devilment & hope . . ." in *Sassafrass, Cypress and Indigo* (1982) to Carrie's witty rebuke to the "chirren" in the autobiographical *Betsey Brown* (1985): "y'all simply sufferin from malnutrition of manners."

Born Paulette Williams in 1948 in Trenton, New Jersey, she changed her name to Ntozake Shange which means "she who comes with her own things" and "she who walks like a lion" in Xhosa, the Zulu language. This photograph was taken in Berkeley in 1982.

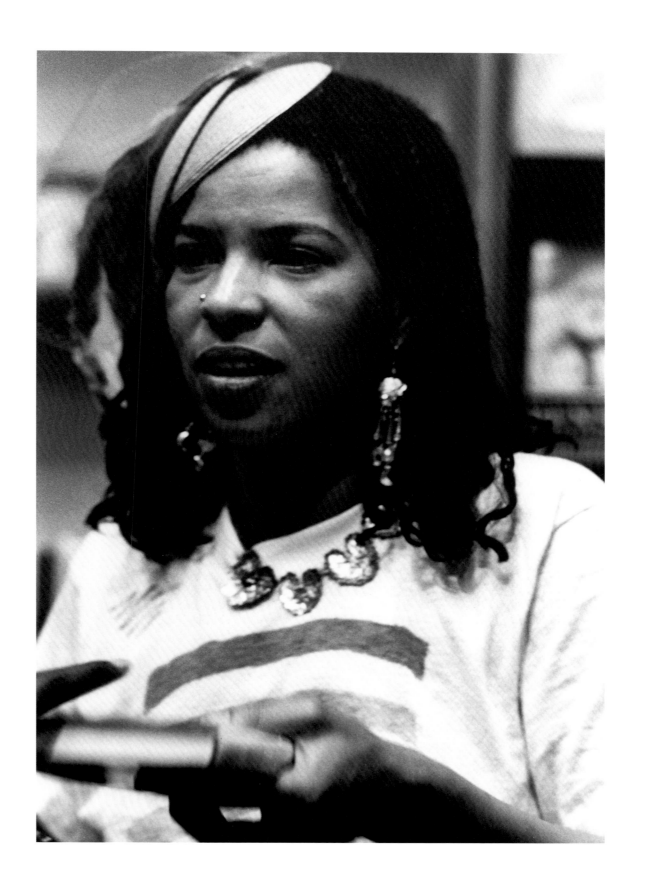

Quincy Troupe

"It is not who or what / you see / but how you see / it," writes Quincy Troupe in his poem "It Is Not." Poet, biographer, editor, and jazz publicist, Troupe sees the world darkly, militantly, imbued with black history and informed by the black diaspora. So identified is Troupe with black vision that he never refers to himself as an individualized "I" but always as "eye": "& eye want to be glory & flow in that light, / want to be coltrane's solos living in me" ("Avalanche").

Above all, Troupe's "eye" sees musically; his poetry strives to break away from the syntax of standard/white English to a blues-infused musicality: "now, poems leap from the snake-tip of my tongue / bluesing a language twisted tighter than a braided hope" ("Boomerang"). African American music is as central to Troupe's project as is poetry. His best-selling collaboration with Miles Davis, *Miles: The Autobiography* (1989), won an American Book Award. Following the jazz masters into improvisations far removed from the original theme, Troupe often breaks language down to sounds, rhythms, puns, and repetitions that create meanings through the reader's associations with history, oppression, and the fundamental blues. Consider, for example, "Up Sun, South of Alaska: A short African-American history song," a poem issuing from the nexus of both a family and racial history: "so now, son black / roll the pages of your american eyes, son, back / black son back . . . back before the run ripped your flesh, here / way way back, sun / son, for the pages of your eyes carry the memory, son / when you hear them, son, they are oral hieroglyphics / blue-black pages in song fingers strum from / african griot songs, secret songs."

Placing himself in the tradition of Paul Laurence Dunbar, Sterling Brown, and Langston Hughes, Troupe celebrates the African American vernacular in language and music. "I don't believe so much in writing schools," he has stated. "American speech idiom—blues and jazz forms—is a viable poetic form. At the base of American creativity is language . . . what black people can do with the rhythms and the words and [what] musicians [can do] with the sounds coupled with the words is extraordinary."

Troupe writes a variable free verse line that ranges from shorter haiku-like meditations ("San Juan Island Image") to the rolling cadences of "Avalanche" and "Song for my Father." In the latter, a praise poem for Quincy Trouppe Sr. (whose name is spelled with two *p*'s), one of the great players of the Negro leagues, the poet conjoins jazz, baseball, filial love, and the perennial black trope of puncturing white pretension: "But you there, father, through it all, a yardbird solo / riffing on bat & ball glory, breaking down all fabricated myths / of white major-league legends, of who was better than who / as bud powell swung his silence into beauty / of a josh gibson home run skittering across piano keys of bleachers."

Troupe, currently teaching at the University of California, San Diego, was born in New York City in 1943. His poetry collections include *Embryo* (1972), the American Book Award–winning *Snake-Back Solos* (1978), *Skulls Along the River* (1984), *Weather Reports* (1991), *Avalanche* (1996), and *Choruses* (1999). This photograph was taken at the poet's home in La Jolla, California, in April 1999.

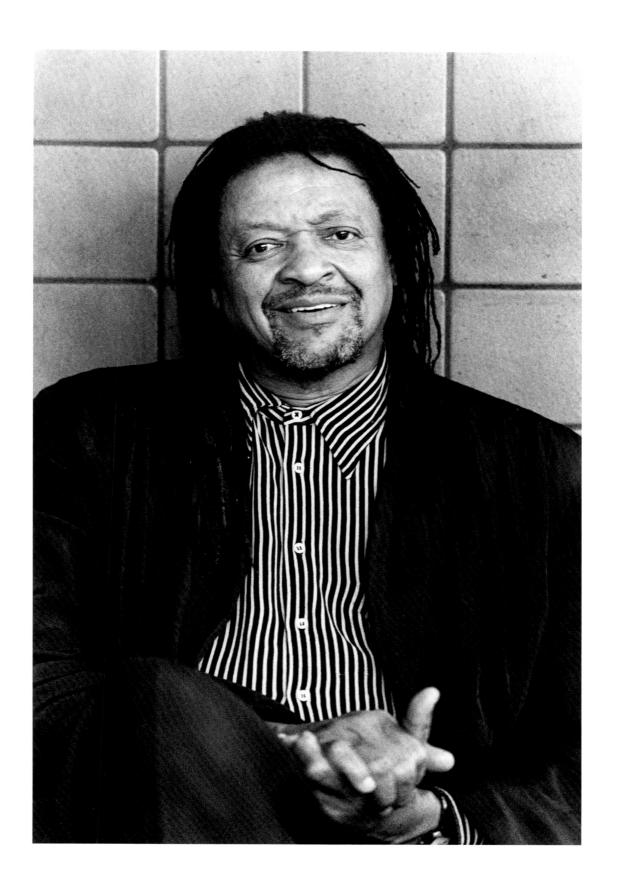

Derek Walcott

Nobel laureate Derek Walcott is the only person, to date, to have received both an O.B.E. (Order of the British Empire) and an Obie, an achievement emblematic of his remarkable range of geographic, artistic, and intellectual activity. For more than fifty years, he has produced poetry and drama of luminous beauty.

Born in 1930 in the Caribbean island of St. Lucia to an English father and a black West Indian mother, Walcott originally conceived of himself as a colonial artist, eagerly adopting the lofty standards of the Western European canon as filtered through the British educational system. "I saw myself legitimately prolonging the mighty line of Marlowe, of Milton," he writes in the introduction to his Obie award–winning play, *Dream on Monkey Mountain* (New York production 1970), "but my sense of inheritance was stronger because it came from estrangement." This classical inheritance, prominent in his often complex, difficult work, would come to major fruition in the epic poem, *Omeros* (1990), which comments on the Caribbean predicament and the wandering Odyssean poet who becomes its spokesperson. As a colonial black, however, Walcott also identified with the writings of Frantz Fanon and Aimé Césaire, striving to reproduce and purify the patois of his island community. As he writes in "Cul de Sac Valley," "If my craft is blest; / if this hand is as / accurate, as honest / as their carpenter's, / every frame, intent / on its angles, would / echo this settlement / of unpainted wood / as consonants scroll / off my shaving plane / in the fragrant Creole / of their native grain." A powerful sense of place infuses his work. A Homeric wanderer seeking home, he re-envisions the entire earth as his heart's geography, his Caribbean birthplace: "this earth is one / island in archi-pelagoes of stars." His enormously successful and enduring plays, *Dream on Monkey Mountain*, *The Sea at Dauphin* (produced 1954), and *Ti-Jean and His Brothers* (produced 1958), reflect the blessings of an acute vernacular lyricism.

Since the mid-seventies, Derek Walcott has spent increasing time as a teacher and writer-in-residence in North American universities. He has taken America into his purview and has become, like the Jamaican Claude McKay, a resonant, peculiarly American as well as Caribbean black voice in poetry. What starts out, in the title poem from *The Arkansas Testament* (1987), as the careful poetic observation of Fayetteville on a winter morning, amplifies, during the course of twenty-four stanzas, into a passionate indictment of the racially divisive legacy of the Old South. Fayetteville turns surrealistically hostile during a dawn sortie for a cup of coffee.

Walcott currently teaches at Boston University. His work includes *Collected Poems, 1948–1984* (1986) and his most recent volume of poetry *Tiepolo's Hound* (2000), as well as *Three Plays: The Last Carnival; Beef, No Chicken; A Branch of the Blue Nile* (1986) and a collection of essays, *What the Twilight Says* (1998). This photograph was taken at the Museum of Contemporary Art, La Jolla, California, in April 2000.

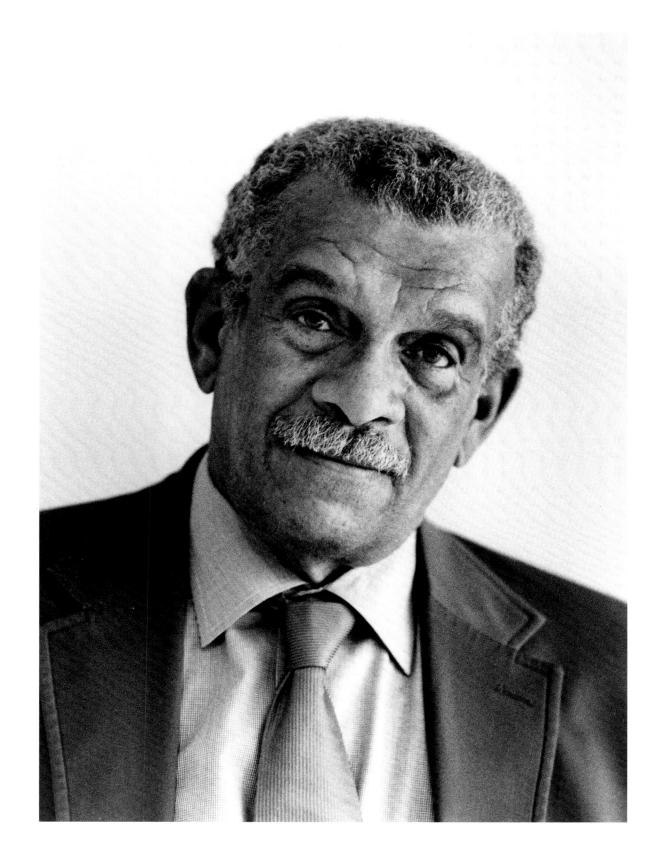

Alice Walker

Novelist, essayist, and poet Alice Walker is perhaps best known for her novel, *The Color Purple* (1982). Community is the sweet glue that binds the characters in this novel together, redefining love, work, and family, providing a context for the creation of culture and tradition.

In the Olinka people, a sense of community belonging becomes the one thing which cannot be stolen from them when the rubber manufacturers decimate the village and the forest. Community provides the context for African scarification—an act unthinkable in much of the Western world, but one in which the Olinka, faced with the loss of all their cultural/tribal identity, can at least carve that identity onto their children's faces so that it will never be forgotten. In the context of community, Celie learns from taking care of Shug that not all nurturing is vampirized and stolen. Loving Shug, Celie reclaims her sexuality, musing to herself, "I wash her body, it feel like I'm praying," lines that powerfully confirm not only a spiritually profound lesbian identity, but the clarity, beauty, and expressiveness of black vernacular. The novel records anguish as well as joy, however, as Nettie asks in great sorrow the same haunting questions that hundreds of thousands of African Americans must have asked about their kinsmen and their ancestors: "Why did they sell us? How could they have done it? And why do we still love them?"

A self-described "womanist" who is fiercely committed to "the spiritual survival, the survival whole of [her] people," Walker provides in the early pages of *Meridian* (1976) what may be the most terrifying and metaphysically accurate paradigm in all of African American literature for the black woman writer whose language has been stolen from her, who is silenced. Walker's Louvinie, a slave woman, literally loses her tongue as punishment for the one creative act allowed her: storytelling. Despite such disturbing themes as African genital mutilation in *Possessing the Secret of Joy* (1992) and the grim depiction of sharecropping as a grotesque mimicry of plantation slavery in *The Third Life of Grange Copeland* (1970), Walker is also well known for such evocative celebrations as the title essay from *In Search of Our Mothers' Gardens* (1983), in which she explores the legacy of creativity, will, and respect for possibilities which she received from her mother.

In addition to several collections of prose, she is the author of *In Love and Trouble: Stories of Black Women* (1973), *You Can't Keep a Good Woman Down* (1981), and *The Way Forward Is with a Broken Heart* (2000) (short stories). Her poetry includes *Once: Poems* (1968), *Revolutionary Petunias and Other Poems* (1973), *Good Night, Willie Lee, I'll See You in the Morning* (1979), *Horses Make a Landscape More Beautiful* (1984), and her collected poems, *Her Blue Body Everything We Know* (1991).

Born in 1944 in Eatonton, Georgia, Alice Walker currently lives in Mendocino County, California. This photograph was taken in conversation with Barbara Christian at KQED studios in San Francisco in 1986.

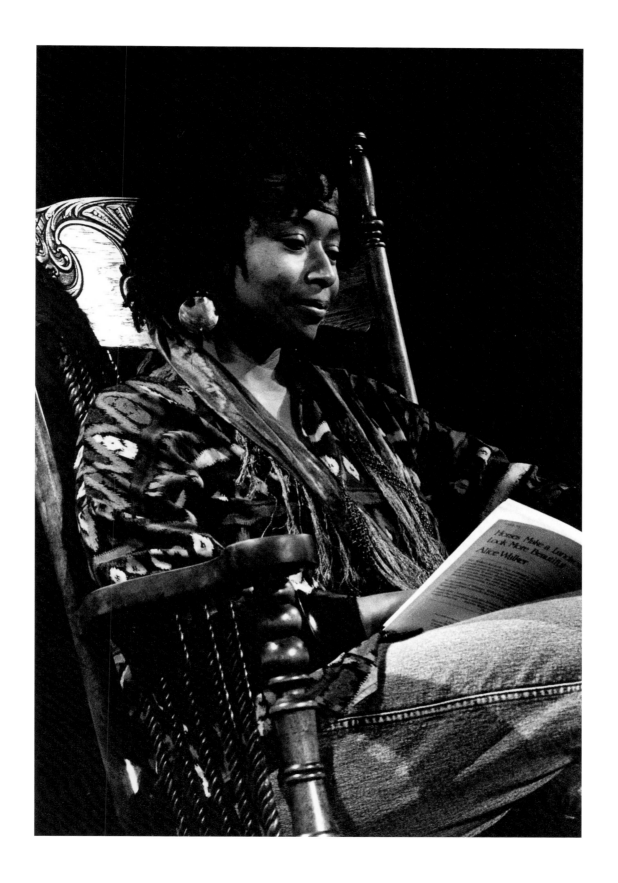

Afaa Michael Weaver

Afaa Michael Weaver is a man resurrected through poetry, risen from black poverty, the dead-end pleasures of male adolescence, and fifteen years of blue-collar labor. In the poem "Eighteen," he describes a steel mill as resembling nothing so much as an actual prison, pernicious and soul-denying: "I am eighteen years old, and I write poems / on the backs of tally sheets for tin. / I read Du Bois and James Weldon Johnson. / The white men hate me. The black men / don't trust me. / I have fourteen years / of this in another factory."

Escaping factory life in part through publication of his first book of poetry at the age of thirty-four, Weaver came to the literary scene with a rich, chastened voice marinated in the beauty and hardship of life. He is a profoundly autobiographical poet, writing with joy and sorrow of his parents, his youth, his children, his heartbreaking solitude. His vision transforms the modest house of his childhood in the poem "Beginnings" into portals of potential transcendence and cosmic communion. "Inside it had no end; the stairs led to God's tongue; / the basement was the warm door / to the labyrinth of the Earth. / We lived on the rising chest of a star." But all this is extinguished with the introduction of violence; when the young boy draws his first blood in a fist fight, "The world became many houses, / all of them under siege."

The deceptive straightforwardness of some of Weaver's verse partially reveals, partially occludes the cataclysms of race, class, and gender which form the nexus of his work and from which he occasionally wrests a hard-won surcease. In "Ego," "God's voice / is caught in / the crackling commotion / of thought, / like dried leaves—breaking." Schooled in the confessional tradition of Gwendolyn Brooks, Jay Wright, and Michael S. Harper (who was his teacher at Brown), Weaver explains, "I write out of a love of language and a desire to express both my innermost feelings and my observations of the world." His verse stands in contrast to the stated political and poetic objectives of the Black Arts poets.

He draws his inspiration from many sources, among them, an appreciation of blues and jazz that anneals his kinship with the bards of an African American tradition. His love of modernist painters, particularly Marc Chagall whose work inspired an entire volume of poetry (*Stations of a Dream*, 1993), carries the personal and racial perspectives to a joyous and sensuous state. "Your heart and mine are too different, / one a bickering roustabout that lounges / in the company of old men, / the other a yellow prodigy / that flies dutifully into the sun" ("The Birthday").

Afaa Weaver was born Michael S. Weaver in 1951 in Baltimore, Maryland. He currently teaches at Simmons College in Boston. His most recent book, *Multitudes: Poems Selected and New* (2000), includes poems from his first five volumes of poetry: *Water Song* (1985), *My Father's Geography* (1992), *Timber and Prayer: The Indian Pond Poems* (1995), *Talisman* (1998), and *Stations in a Dream* (1993). He is also the author of several plays. This photograph was taken in Somerville, Massachusetts, in June 2000.

John Edgar Wideman

John Edgar Wideman is a singular force in American letters; he is a stunningly original, lyrical writer, meticulous, expansive, visionary, the possessor of a fiercely beautiful, anguished imagination. African American identity and consciousness provide not only his subject matter, but the poetics of his narrative style. As he himself has observed, "The blackness of my writing inheres in its history, its bilingual, Creole, maroon, bastardized, miscegenated, cross-cultural acceptance of itself in the mirror only it can manufacture."

In discussing his own fiction, he provides a partial explanation for some of the enormous power of African American literature. African Americans, he suggests, "have become experts at living in at least two places simultaneously, cultivating a sensitivity to the distance—comic, ironic, tragic—between our outer and inner lives. For us music, speech, and body movement are repositories for preserving history, values, dignity, a sense of ourselves as separate, whole. Double-entendre, signifying, mimicry, call-and-response patterns of storytelling, oratory and song, style as cutting edge, as a weapon against enforced anonymity have been honed to display and protect our secrets."

Cattle Killing (1996), a mysterious, brooding, incantatory novel, is haunted by an image of the Xhosa, "a brave, elegant African people who had resisted European invaders until an evil prophecy convinced them to kill their cattle." As in his earlier *Sent for You Yesterday* (1983), characters, centuries, continents coalesce in this profoundly nonlinear, mythic novel. His nonfiction too reveals an America that simultaneously is mesmerized by and despises African Americans, as in his exploration of the tragically American racial/cultural context for the

police violence against Rodney King: "Rodney King makes me think of something white. The bulk of him on his knees, flopping over on his back, twisting, lurching, he's the great white whale, skewered by harpoons, tethered by ropes, surrounded by his tormentors, hunters who have pursued and landed him, who desperately try to subdue the mystery he represents with blows of their clubs." His 1984 memoir *Brothers and Keepers* explores not just the story of his imprisoned brother Robby, but his own struggle to write authentically, to examine his own motivations and impulses; in the process, he invites the reader to make a similarly exacting self-examination.

Born in Washington, D.C., in 1941, John Edgar Wideman is a professor of English at the University of Massachusetts, Amherst. Rhodes scholar, Phi Beta Kappa, winner of the MacArthur "genius" award, and two-time winner of the PEN/Faulkner award, Wideman is the author of nine novels, including: *A Glance Away* (1967), *Hurry Home* (1970), *The Lynchers* (1973), *Hiding Place* (1981), *Reuben* (1987), *Philadelphia Fire* (1990), and *Two Cities* (1998), as well as three collections of short stories, two nonfiction collections, and numerous essays and articles. This photograph was taken in Salt Lake City, Utah, in October 2000 at the African American Literature and Culture Society conference.

John A. Williams

It is appropriate that John Alfred Williams's first published novel was entitled *The Angry Ones* (1960), for Williams has claimed the terrain of black anger as his personal territory. Born thirteen years after Richard Wright, Williams carried Wright's torch of naturalistic black protest writing into the second half of the twentieth century.

Wright himself is portrayed as the father figure of black writers in Williams's best-known novel, *The Man Who Cried I Am* (1967). As Harry Ames, Wright's doppelganger, talks to Max Reddick, the novel's younger protagonist, Williams allows him to articulate the *raison d'être* of his own artistic existence: "'I'm the way I am, the kind of writer I am, and you may be too, because I'm a black man; therefore, we're in rebellion; we've got to be. We have no other function as valid as that one.'" The novel is an apocalyptic vision of race war. Dying of rectal cancer, Reddick is murdered instead by the cancer of racism, his death ordered because he has discovered both a worldwide conspiracy to destabilize emerging African countries, and an elaborate FBI/CIA/National Security Council "contingency plan" to herd twenty-two million black Americans into concentration camps in the event that "America, sitting on a bubbling black cauldron," finds that it cannot adequately control black unrest. Max's literary agenda clearly emulates Williams's—and not just in this novel: "He wanted to do with the novel what Charlie Parker was doing to music—tearing it up and remaking it; basing it on nasty, nasty blues and overlaying it with the deep overriding tragedy not of Dostoevsky, but an American who knew of consequences to come; Herman Melville . . . a Benito Cereno saddened beyond death." Williams's most recent novel, *Clifford's Blues* (1999), a fictionalized diary of a black homosexual jazz musician who gets rounded up by the Nazis in 1933, continues this revealing musical leitmotif.

Despite Williams's justifiable outrage, his fiction explores the difficult utopian possibilities of compassion, particularly in *Captain Blackman*, a 1972 science fiction novel that involves time travel and a black takeover of American nuclear defense systems. Blackman, a soldier heroically wounded protecting his men from an ambush in Vietnam, hallucinates his participation in each of America's wars. Despite some scenes in which Blackman conflates retaliatory rape with manliness, for most of the novel Blackman struggles not to respond in kind to racial hatred: "without [compassion], I become like *them* and to be like *them* is to *be* them."

Williams's range of writing interests is as broad as the canvas of his novels, among them, *Sissie* (1963), *The Junior Bachelor Society* (1976), and *!Click Song* (1982). His short story, "Son in the Afternoon," has an angry and triumphant protagonist who is the mirror opposite of Toni Morrison's subsequent creation, the character Pecola Breedlove. Williams has published biographies of Martin Luther King and Richard Wright, travelogues, sociological nonfiction, drama, librettos, and recently, *Safari West* (1998), a volume of poetry that won the American Book Award.

Williams was born in Jackson, Mississippi, in 1925; retired from Rutgers University, he lives in Teaneck, New Jersey. This photograph was taken in San Francisco in April 2000.

Sherley Anne Williams

Novelist, poet, and playwright Sherley Anne Williams is perhaps best known for *Dessa Rose* (1986), a novel based on the fictional meeting of two actual historical figures: a pregnant black woman who helped lead a slave uprising while chained in a coffle and a North Carolina white woman who gave sanctuary to slaves. As their lives become entangled, the history of black women and white women is reinscribed. Without sentimentalizing or denying, Williams also reinscribes the hideous and unspeakable, as in the scene in which Harker kisses tenderly and reclaims as beautiful Dessa's whipscarred, branded thighs. Based on a blues structure of repetition and variation of a central motif, the prologue, begun with laughter and desire, is abruptly and brutally shattered by Kaine's murder. The novel chronicles Dessa's retaliation, subsequent captivity and interrogation, her resistance and escape, and her evolving love not only for Nathan and Harker, but also for Ruth.

Her earlier *Peacock Poems* (1975), nominated for both a Pulitzer Prize and a National Book Award, introduces Odessa, namesake and touchstone for *Dessa Rose*. Forced to live in a world in which speech and naming is forbidden, even the right to name her own children, Odessa paradoxically claims the power of naming: "I say yo name / now and that be love. I say / yo daddy name and that be / how I know free. I say Harker / name and that be how I / keep loved and keep free." Williams's *Some One Sweet Angel Chile* (1982) was also nominated for a National Book Award, and a television performance of its poems earned an Emmy. The collection opens with a series of epistolary poems: "Letters from a New England Negro," subsequently performed as a full-length, one-woman drama at the National Black Theatre Festival (1991) and the Chicago International Theatre Festival (1992). The poems are full of evocative, piercing small ironies, such as Hannah's quiet moments of resistance. Her refusal to wear a headscarf or braid her hair is a refusal of a symbol of subservience and slavery, yet the plaiting—required by whites—becomes an emblem of tenderness between black mothers and daughters. The collection's middle section, exuberant, boisterous, and sexy, skips sixty years to the 1930s to celebrate a similar spirit of rebelliousness, in the persona of famed blues singer Bessie Smith. In these poems, Bessie Smith, the "angel chile," the wild woman of the traditional blues song, is not mythologized but remembered for the ways in which her spirit brought courage, hope, and humor into the lives of others. As the poem "WITNESS" sternly warns us, Williams's narrators speak not only for themselves, but for generations which preceded them and generations to come: "I give voice / to the old stories. / This is not romance, private fictions."

Born in 1944 in Bakersfield, California, Sherley Anne Williams was a professor of literature at the University of California at San Diego from 1975 until her death at age fifty-four on July 6, 1999. Her other work includes "Meditations," the novella that became *Dessa Rose* (written partly as a repudiation to William Styron's *Confessions of Nat Turner*), two children's books, and *Give Birth to Brightness: A Thematic Study in Neo-Black Literature* (1972). This photograph was taken at Cody's Books in Berkeley in 1986.

August Wilson

August Wilson is one of America's most distinguished playwrights ever. Unlike Eugene O'Neill, Arthur Miller, Tennessee Williams and other Euro-American dramatists, however, Wilson has committed himself to portraying the story of a race. When asked by an interviewer if he wrote from an autobiographical perspective, Wilson replied, "Well, you know I've got a 400-year autobiography. . . . And I claim the right to tell it in any way I choose because it's, in essence, my autobiography—only it's the story of myself and my ancestors."

Wilson chooses to work primarily within the confines of realism, but he does so through his presentation of dreams, visions, songs, communal rites, and, to use Baldwin's phrase, the evidence of things unseen. With a poet's sensibility he deepens his vision through an evocative use of metaphor, finding in black life what he describes as "a very elegant kind of logical language, based on the logical order of things . . . there's the idea of metaphor. For instance, when one character in *The Piano Lesson* [1990] asks, 'What time does Berneice get home?,' instead of getting a response like, 'Berneice gets home at five o'clock,' you get: 'you up there asleep, Berneice leave out of here early in the morning, she out there in Squirrel Hill cleaning house for some big shot down there at the steel mill. They don't like you to come late. You come late, they won't give you your carfare. What kind of business you got with Berneice?' When you ask a question, instead of getting an answer to the question, you get this guy's ideas, his opinions about everything, a little explanation." In *The Piano Lesson*, the piano itself is more than a family heirloom; it is the repository of the Charles family history, purchased using the slave great grandparents as currency, brought into the family through the

death of the father, and the object of contention between the children.

All of Wilson's stage characters speak an oxygenated, poetic black English, a rich and joyous defiance of the surrounding oppression, transcended through the language and vibrancy of Wilson's unforgettable characters: Harold Loomis, returning from seven years of slave labor on a Southern chain gang; the legendary blues singer Ma Rainey; and Troy Maxson, a former Negro Leagues baseball player, now an embittered and controlling husband and father. Wilson has been influenced by Baraka's Black Nationalism, Jorge Luis Borges's storytelling, Romare Bearden's paintings, and most of all, by the blues.

Wilson's most important plays have been written as part of a projected ten-play cycle covering each decade of the twentieth century: *Jitney* (1982), *Ma Rainey's Black Bottom* (1985), *Joe Turner's Come and Gone* (1988), *Two Trains Running* (1992), and *Seven Guitars* (1996), as well as *Fences* (1987) and *The Piano Lesson* (1990), both of which garnered Pulitzer prizes.

August Wilson was born in 1945 in Pittsburgh, Pennsylvania, the northern urban setting of many of his plays. This photograph was taken in March 2000 at the Seattle Repertory Theater in a public dialogue with novelist Charles Johnson, celebrating the opening of Wilson's play, *King Hedley II.*

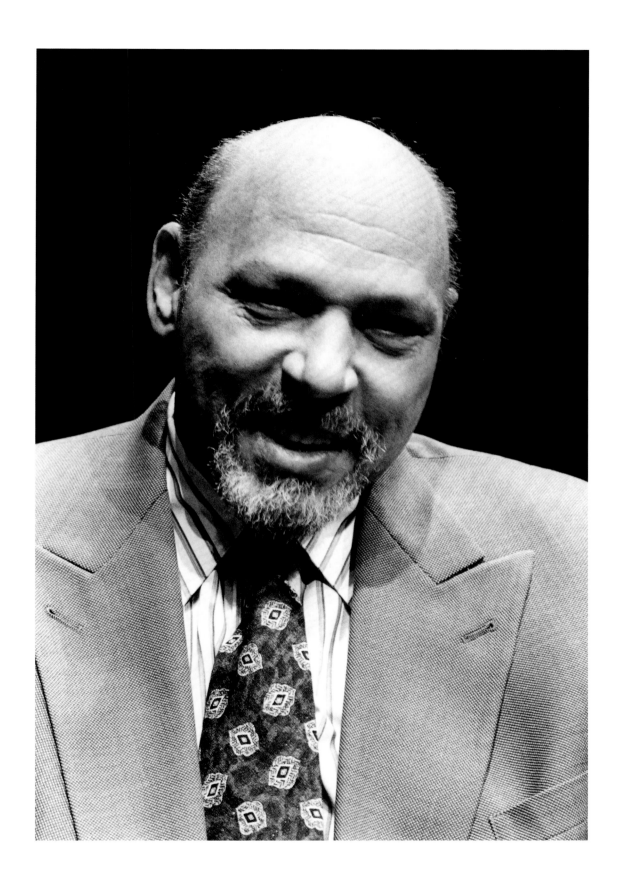

Al Young

For more than forty-five years, poet, memoirist, musician, screenwriter, and novelist Al Young has pursued the profound connection between language and music, so tightly interwoven in his poetry that in "Distances" (*Conjugal Visits*, 1996) physical space becomes subject to the same rules as improvisational composition: "The distance anywhere—from birth to death, / from sit to stand, from heat to holy snow— / invents itself, unravels as you go." Young defines his poetry as an effort "to fly, to sail, to jump and leap and jaywalk," the poem "a magic wafer you take / into your mouth / & / swallow for dear life." *Heaven: Collected Poems 1956–1990* (1992) gathers poems from *Dancing* (1969), *The Song Turning Back Into Itself* (1971), *Geography of the Near Past* (1976), and *The Blues Don't Change* (1982).

His pathbreaking work as a writer of musical memoirs has created a legacy for younger writers like Quincy Troupe, known for his remarkable musical memoirs of jazz legend Miles Davis. Young's first musical memoir, *Bodies & Soul* (1981), addresses the lives and music of artists from Ray Charles and Duke Ellington to Rossini and El Trio Los Panchos. Preceded by *Kinds of Blue* (1984) and *Things Ain't What They Used to Be* (1987), *Mingus/Mingus: Two Memoirs* (1989), Young's fourth musical memoir, is a project coauthored with Janet Coleman. Each composed a memoir of life with jazz composition and performance legend Charles Mingus. Together, the two memoirs have the vibrant contextual interplay of the musician's own alternate takes, using the life and career of Charles Mingus as the original composition from which to create the variations and differences of this extraordinary collaborative project. Young's memoir foregrounds the presence of the jazz legend throughout Young's life—from hearing that new strange sound the first time on the radio to riding shotgun with Charles Mingus himself.

Much of Young's fiction, too, claims music as part of its spiritual and thematic center. His first novel, *Snakes* (1970), is the story of a young man's quest to become a jazz musician. MC's "tough but gentle" Uncle Tull, a literary double for Al Young himself, offers practical wisdom along with his piano lessons: "Just take your time, one note at a time . . . that's all it is to playin the piano or anything else. Take your time and work it out." However, MC's friend Champ, when he describes an uncle who "picks up one of these plastic ukuleles from out the dimestore and play some old funkybutt blues make you cry," reveals that it is the heart of the blues player, and not the instrument, that makes the music.

Young's other novels include *Sitting Pretty* (1976), *Who is Angelina?* (1975), *Ask Me Now* (1980), and most recently the offbeat and engaging *Seduction by Light* (1988). Once calling himself "an uncredited, backroom writer in Hollywood," Young has worked on numerous screenplays—among them *Sparkle* (1976) and *Bustin' Loose* (1981). He is the founding editor (with Ishmael Reed) of the multicultural *Yardbird Reader* and several other influential journals, a longtime director of the Associated Writing Programs, and a highly regarded teacher of creative writing at Stanford University and elsewhere.

Born in Ocean Springs, Mississippi, in 1939, Al Young currently lives in Berkeley, California, where this photograph was taken at the Watershed Poetry Festival in September 2000.

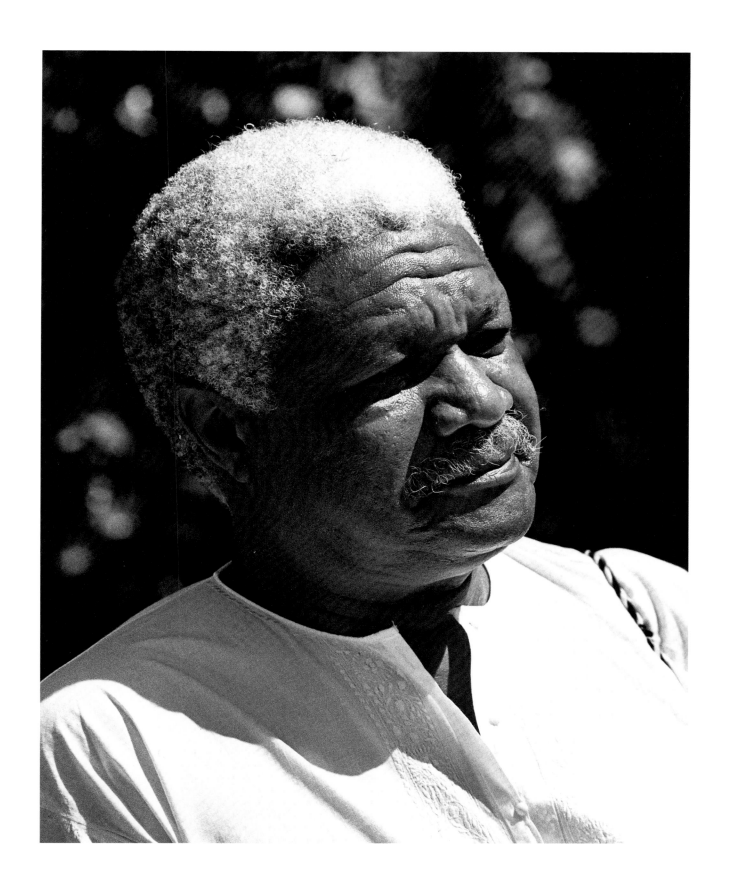

ACKNOWLEDGMENTS

Many, many people helped make this book possible. Three of them were uncommonly generous with their skills, ideas, and time: my research assistant Sam Patterson (AKA Bartelby), who spent his MFA year—and many more hours than my grant actually covered—rustling up books and preliminary research materials for the literary biographies and helping me think through many of them; Professor Robert Philipson, who offered invaluable suggestions and editorial advice on several of the biographies; and Patti Levey, who more than twenty years ago became my artistic collaborator when I became too allergic to darkroom chemicals to continue solo printing. I also owe much to the exemplary darkroom skills of photographer Gene Nocon. It is my great pleasure to thank Professor Wilfred Samuels for his enthusiastic and long time support of my photographs of black writers and especially for his support of this project and the two exhibits in Salt Lake City that he arranged as part of the Looking Back with Pleasure II conference in October 2000. To George Kanakis, who framed all the prints for the traveling exhibit that is part of this project and who took on this project like a proud uncle, I hope you know how much your care and skills as a framer—and your friendship—have meant to me. To Mary Yearwood, Curator of Photographs and Prints at the Schomburg Center for Research in Black Culture, who helped arrange an exhibit at the Schomburg of these photographs and who has been a wonderful ally of this project: thank you so very much! To the writers included here whose extraordinary kindness and friendship often made this project completely magical, I offer more appreciation than I can ever express. To Seetha Srinivasan and Anne Stascavage, my editors at the University Press of Mississippi, who believed in this project and who with unfailing humor, good-naturedness, and patience saw it through to the (overdue) end: thank you! And there are many more it is my great pleasure to thank, among them those colleagues at San Diego State University who acknowledged and supported the relevance of my photographic work to my scholarly work, especially my department chair, Carey Wall; the scholars in African American literature who first encouraged my writing in this area, especially Barbara Christian, Frances Smith Foster, and Skip Gates; all the women in my No Limits Artists Group (with a special thank you to Anita Carol Smith) for helping me make the transition back to being an artist again; many wonderful students with whom I have had the pleasure of sharing my love for African American literature, especially Kenneth Slack, now my colleague and friend and the most extraordinary reader of poems I know; and finally—and with enormous gratitude—I thank the many friends whose love, encouragement, and support have meant everything to me, among them Wendy Lynne Smith, Kirsten Walker, Alice Philipson, Lois Simonds, Hans Rieke, Hannah Moeckel-Rieke, Doug Nelson, Cris Downing, River Malcolm, Janette Kiehn, Carol Jenkins, and most especially, and with much affection, Susan Wyche. And finally, I would like to thank a gentle, wise, and wonderful man: Alan Newman, M.D., who promised to pull me through chemo the year I started this project, and did.

—Lynda Koolish

BEVERLY PUBLIC LIBRARY

3 1400 00369 7443

DEC 2001

DEC 2001